BIG IDEAS

Concepts Developments Explanations Solutions

General Editor: **Roger Walton**

BIG IDEAS

First published in 2002 by:
HBI, an imprint of HarperCollins Publishers
10 East 53rd Street
New York, NY 10022-5299
United States of America

Distributed to the trade and art markets
in the U.S. by:
North Light Books,
an imprint of F&W Publications, Inc.
4700 East Galbraith Road
Cincinnati, Ohio 45236
Tel: (800) 666-0963

Distributed throughout the rest
of the world by:
HarperCollins International
10 East 53rd Street
New York, NY 10022-5299
Fax: (212) 207-7654

ISBN: 0-06-008754-4

Conceived, created, and designed by:
Duncan Baird Publishers
6th Floor, Castle House
75–76 Wells Street, London W1T 3QH

Designer: Claire Harvey
Editor: James Hodgson
Project Co-ordinator: Tamsin Wilson

10 9 8 7 6 5 4 3 2 1

Typeset in MetaPlus
Color reproduction by Scanhouse, Malaysia
Manufactured in China by Imago

NOTE
All measurements listed in this book
are for width followed by height.

So, what's the **big** idea ?

The conceptualization of any project is one of the designer's most important contributions to its success. Most of the parameters within which the designer has to operate—such as subject or product, communication objectives, budget, and schedule—are defined by the client commissioning the project. (These constraints apply even when client and designer are one and the same.) As this book shows, an imaginative designer adopting a flexible approach can overcome the most restrictive limitations to create original, engaging work that communicates its message fluently to its viewers, readers, or users.

So, what's the **big** idea ?

There's no secret formula for conceiving big ideas, no cunning shortcut. We need to analyze the design problem before us, and then find a way of stepping out of everyday channels of thinking. For a jump start out of "thinking by numbers," look here for inspiration: see, for example, how media as diverse and unconventional as buses, jello, inflatables, and rubble have been used to entertaining, evocative, intriguing, or poignant effect.

So, what's the **big** idea ?

Big Ideas is here to help you discard the humdrum, focus on key communication objectives, and make space in your mind for your own big idea.

section **1234567890**

ideas for us

LIFE LESSON # **27**

Worry and doubt can actually be prayers and visualizations — and self-fulfilling programming — for things you do not want.

self-

fulfilling programming

how to be

HAPPY,

dammit

a **cynic's** guide to spiritual happiness

written by karen salmansohn design by zinzell

How to Be Happy, Dammit

An original and witty response to the self-help genre, this book proposes 42 life lessons. Each lesson is accompanied by arresting metaphorical imagery. The typography and page layout support and enhance the originality of the concept, sustaining the reader's interest and enjoyment throughout this 236-page book.

The skilful use of a consistent color palette pulls together very diverse imagery that might otherwise seem unrelated.

Only you feel it's more like: "No pain, no Rogaine."

Meaning?

Growth can come from places you thought were dead, barren, and **disappointing.**

LIFE LESSON #2

That pain back in LIFE LESSON #1 was for your benefit.

You were being taught to breathe, invited to suck down a yummy oxygen/nitrogen cocktail. That painful whack was necessary for your growth.

Yes,

thoughts, too, have

energy.

Designer
Don Zinzell

Illustrator
Don Zinzell

Photographer
Don Zinzell

Design Company
zinzell

Country of Origin
USA

Description of Artwork
Book adopting a humorous approach to the self-help genre

Dimensions
152 x 178 mm
6 x 7 in

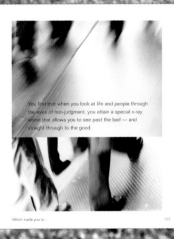

LIFE LESSON #17

You find that when you look at life and people through the eyes of non-judgment, you attain a special x-ray vision that allows you to see past the bad — and straight through to the good.

You must celebrate Non-Judgment Day, then Non-Judgment Year, then Non-Judgment Life.

You accept: you live in a world of uncertainty. This uncertainty ingredient is what makes for that hot and inimitable entrée called "The Future" — otherwise all would be permanently frozen in time.

LIFE LESSON 20

You must have Great Non-Expectations.

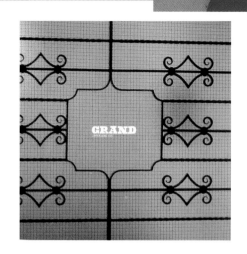

Grand (Ampersand No.5)

This analysis of the typography used over a kilometer of the city of Melbourne is a joyful appreciation of the vernacular use of typefaces. The book provides an opportunity for quirky observation and imaginative presentation of data, as well as being a novel way to promote a studio.

OTHER
67

CLARENDON
4

PALA
7

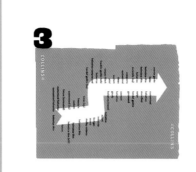
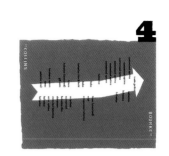

The entire book, including the cover,
is printed on self-adhesive stock.

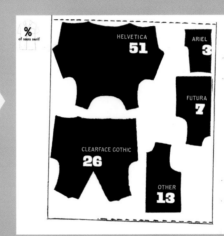
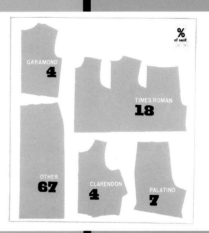

Designer
Stephen Banham

Photographer
David Sterry

Design Company
The Letterbox

Country of Origin
Australia

Description of Artwork
Book

Dimensions
145 x 145 mm
$5^3/_4$ x $5^3/_4$ in

Elizabeth Roberts Self-Promotion

Although linked by 1940s-style *film noir* imagery, these postcards use different techniques to convey their message. The postcard on this page juxtaposes modern and retro elements—both in terms of typography and imagery. The card on the opposite page shows how self-deprecation can be used as a tool for self-promotion, with its bathetic motto and modestly expressed list of attributes at the bottom.

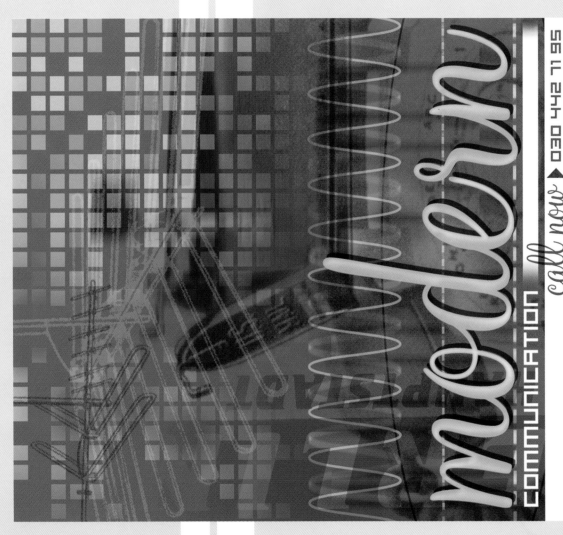

Designer
Elizabeth Roberts

Photographer
Elizabeth Roberts

Country of Origin
Germany

Description of Artwork
Self-promotional postcards

Dimensions
105 x 148 mm
4¹/₄ x 5³/₄ in

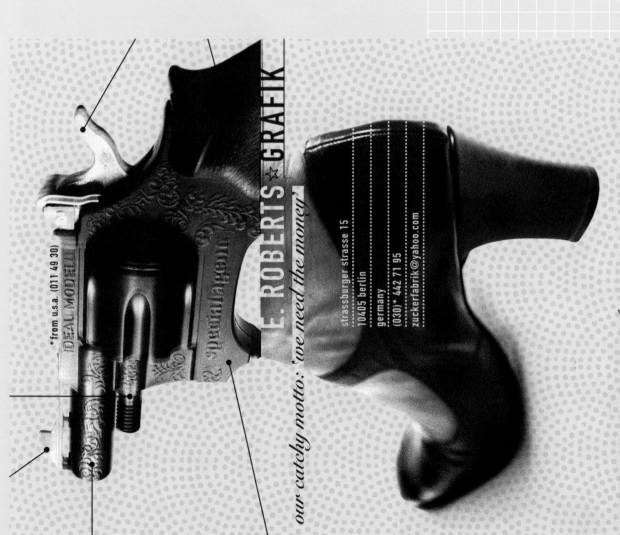

*from u.s.a. (011 49 30)

IDEAL MODELL

Spezialagentur

E. ROBERTS ☆ GRAFIK

our catchy motto: 'we need the money'

strassburger strasse 15
10405 berlin
germany
(030)* 442 71 95
zuckerfabrik@yahoo.com

notes:

1 ILLUSTRATION
2 DARE I SAY ART
3 PLAIN OLD GRAPHIC DESIGN
4 BAD GERMAN GRAMMAR

POSTCARD 002
IMAGE FROM A MOTION GRAPHICS SEQUENCE CREATED
BY D-FUSE FOR JAPANESE TELECOMMUNICATIONS GIANT
NTT DoCoMo TV ADVERTISING CAMPAIGN.

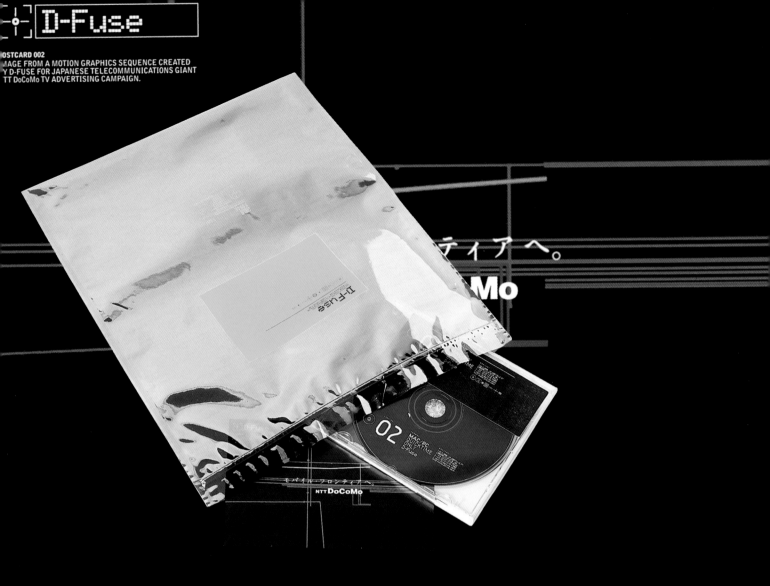

D-Fuse Press Pack

By using an overtly protective packaging for this self-
promotional press pack, the designers give the
impression that its contents should be handled with
care. The translucent nature of the material gives the
impression of items in a suitcase viewed under an airport
X-ray machine. This all serves to engage the attention
of the recipient, thereby increasing the chances of the
package successfully promoting the studio.

Designers
D-Fuse

Art Director
Michael Faulkner

Design Company
D-Fuse

Country of Origin
UK

Description of Artwork
Updateable press pack
including brochure
and video CD

Dimensions
Various

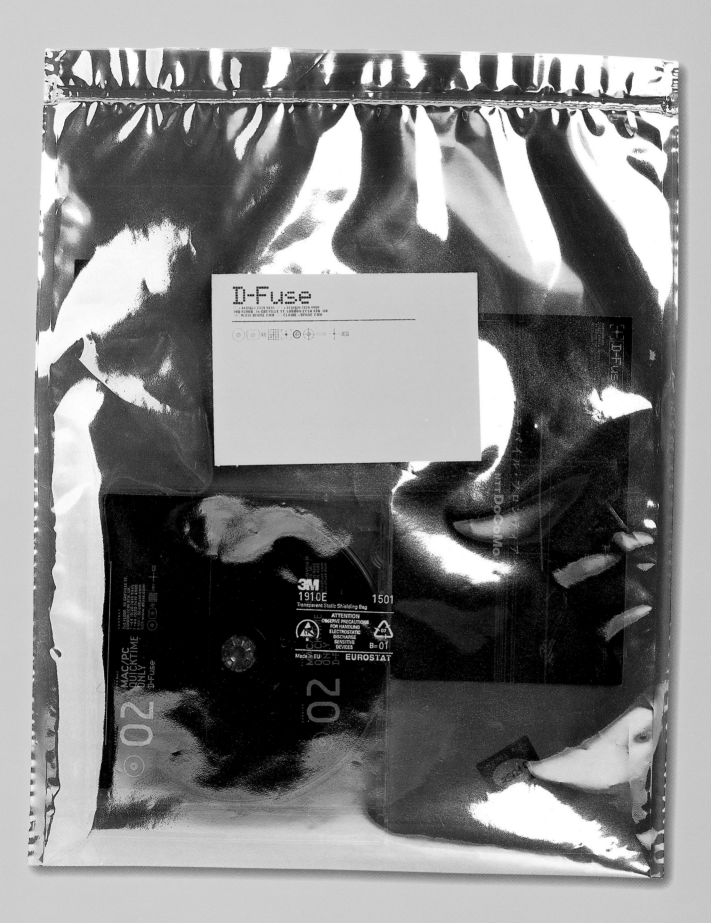

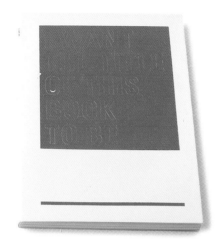

I Want the Title of this Book to Be

This award-winning design for a collection of work by the studio H55 brings audience participation to the fore. The reader/user is invited to formulate his or her own title by rearranging some of the letters from the set-up phrase "I want the title of this book to be." The typeface resembles children's plastic fridge-magnet letters, perhaps acting as a subliminal encouragement to experiment.

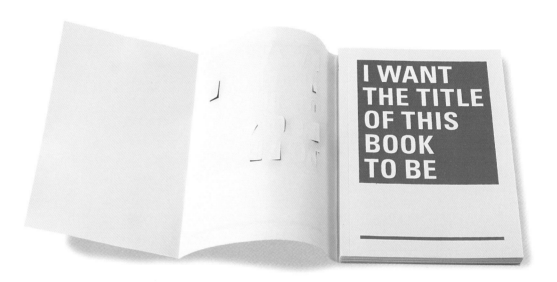

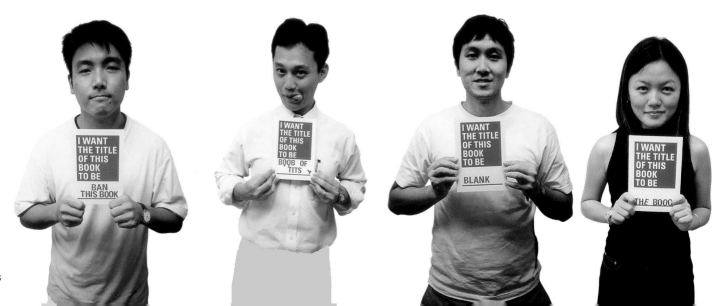

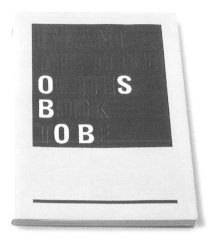

The self-adhesive letters are die-cut into the red printed area on the dust-jacket, so that they can be pushed out and juggled before the user affixes his or her final offering in the space provided on the bound cover.

Designers
Hanson Ho,
Stanley Chek

Design Company
H55

Country of Origin
Singapore

Description of Artwork
Self-promotional book
showing H55's past work

Dimensions
148 x 210 mm
5³/₄ x 8¹/₄ in

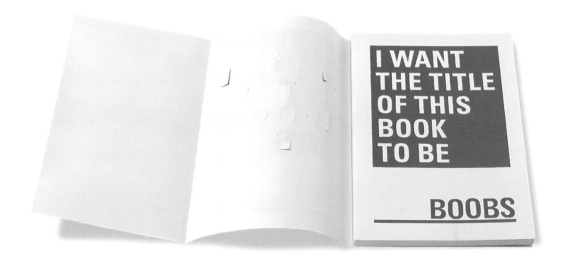

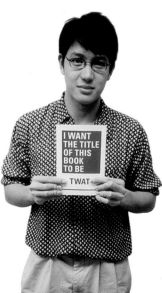

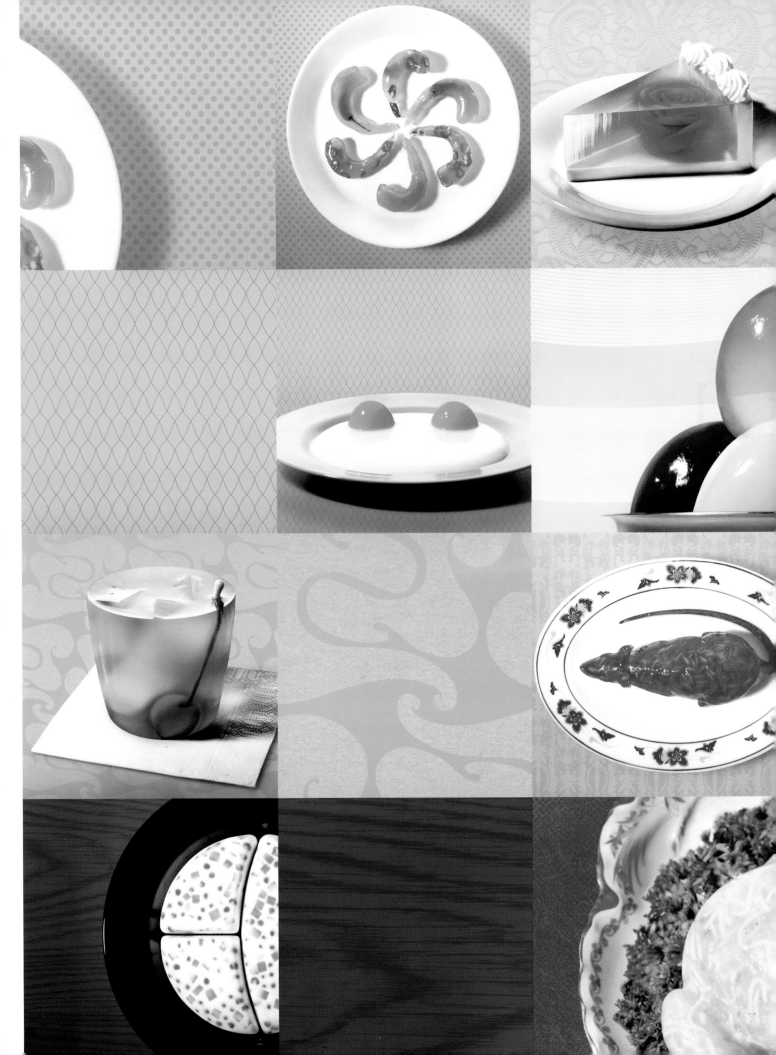

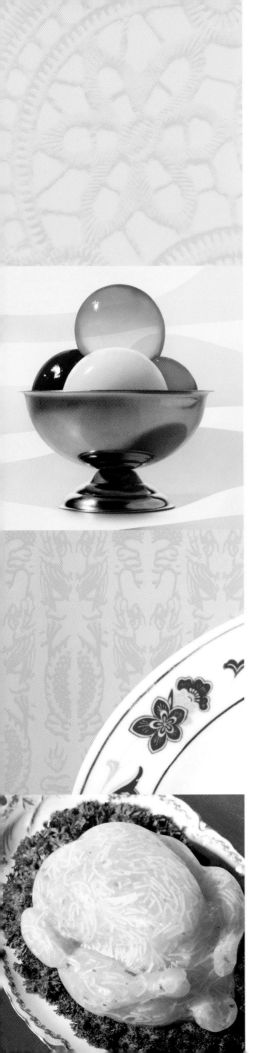

The Joy of Jello

This wonderfully original and lovingly executed degree project is a visual interpretation of a collection of German texts that focus on memory and identity in relation to food. The use of jello as a medium reflects these themes: it takes us back to the childhood experiences that can be so influential in the formation of our personalities. And as Bill Murray says in *Ghostbusters*: "There's always time for jello."

Designer
Elizabeth Roberts

Art College
Hochschule der Künste, Berlin

Country of Origin
Germany

Description of Artwork
Series of 8 color photographs printed on aluminum

Dimensions
420 x 595 mm
16¹/₂ x 23¹/₂ in

The principal objects were formed out of gelatin set in hand-made latex molds and photographed in the studio on their plates. The two-dimensional backgrounds were then added digitally, and make reference to atmospheric and narrative details in the texts.

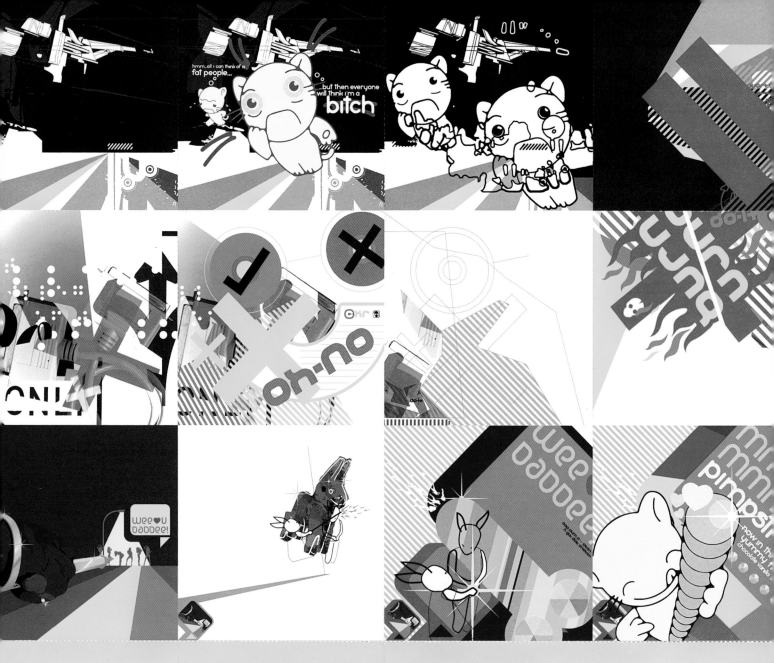

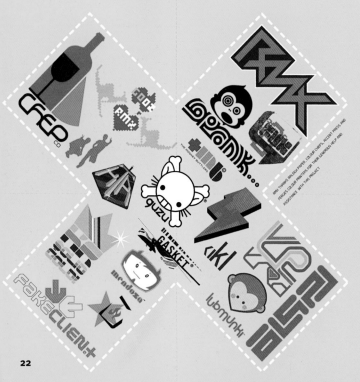

Designers
Rinzen

Design Company
Rinzen

Country of Origin
Australia

Description of Artwork
Two double-sided and perforated posters, showing the results of a "visual remixing" game, with accompanying stickers and music CD

Dimensions
Package: 200 x 200 mm
8 x 8 in
Poster 1: 800 x 600 mm
$31^1/_2$ x $23^1/_2$ in
Poster 2: 400 mm x 400 mm
$15^3/_4$ x $15^3/_4$ in

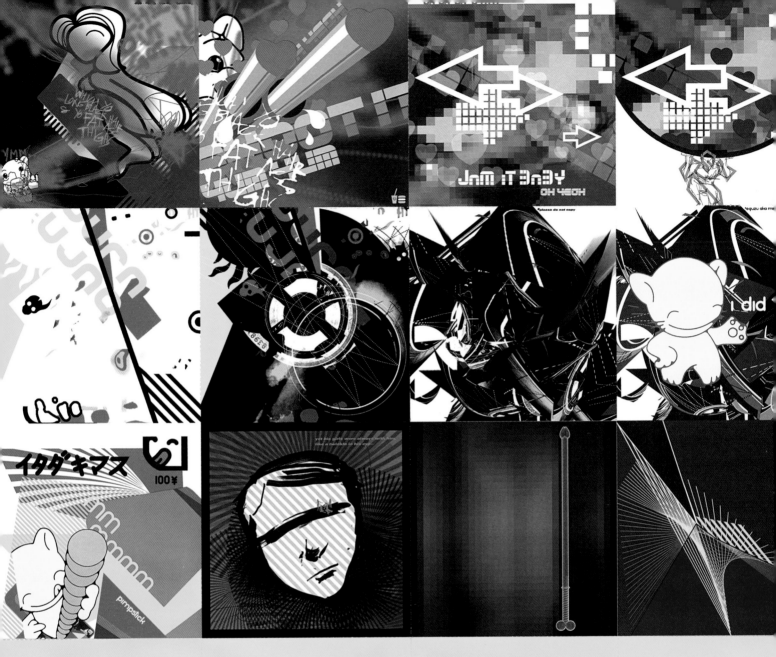

RMX//A Visual Remix Project

Rinzen have reworked the "Exquisite Corpse" game (in which a story is woven by different people, each writing a sentence having seen only the previous sentence). In *RMX*, an initial artwork on a given theme is passed from player to player, each "remixing" the image by altering, adding, or erasing elements within it.

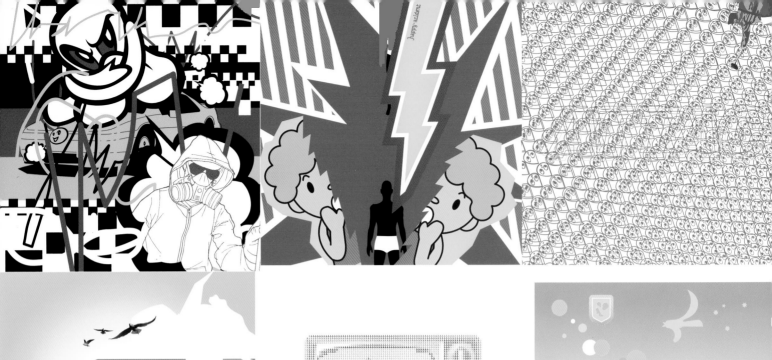

Rinzen Presents RMX Extended Play

Following on from *RMX//A Visual Remix Project* (see pp.22–3), *RMX Extended Play* broadens the scope of Rinzen's "remixing" game by including players from all corners of the globe. The artworks shown on this page are from separate games, whereas the next spread traces the development of a single theme—"Happy Accident"—from left to right then top to bottom.

(this and following spread)
Designers
Rinzen in collaboration with designers, artists, and illustrators from around the world, including the following whose offerings are shown here: Designershock, The Designers' Republic, Superfun, Surfacepseudoart

Design Company
Rinzen

Country of Origin
Australia

Description of Artwork
Book showing the results of Rinzen's "RMX" game. To accompany the book there is a CD containing music and data, as well as a sheet of stickers featuring comments intended to pre-empt viewers' criticisms.

Dimensions
Book: 240 x 240 mm
$9^1/_2$ x $9^1/_2$ in

ARE THEY SUPPOSED TO
MAKE THEM WORSE?

Like any game *RMX* has rules: images
are passed on by e-mail, so only vector
art is allowed; each player is given a
deadline of a week; strict anonymity is
observed—only Rinzen know the
players' identities.

I FEEL LIKE I'VE BEEN
POKED IN THE EYE
WITH A SHARP, BADLY
TRACED STICK

A REGRETTABLE DAY FOR
GRAPHIC DESIGN, INDEED

IT'S NOT ON FIRE BUT
I'M GOING TO PISS ON
IT ANYWAY

Acknowledging the debt the project
owes to remixed music, the chaos and
unpredictability of the samples on the
accompanying audio CD complements
the visual remixing.

MAKE IT STOP! PLEASE!

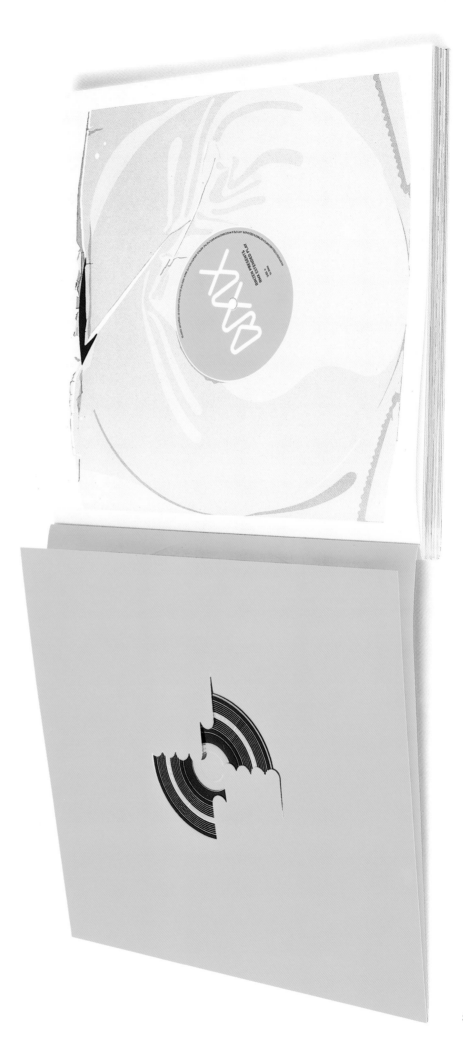

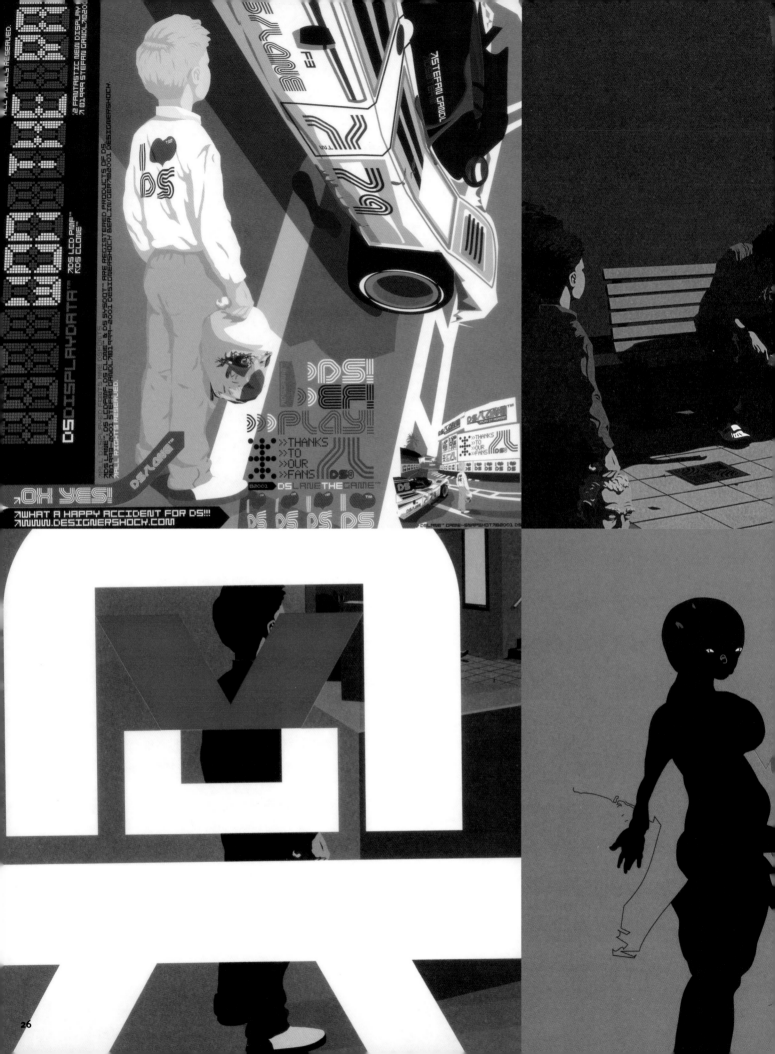

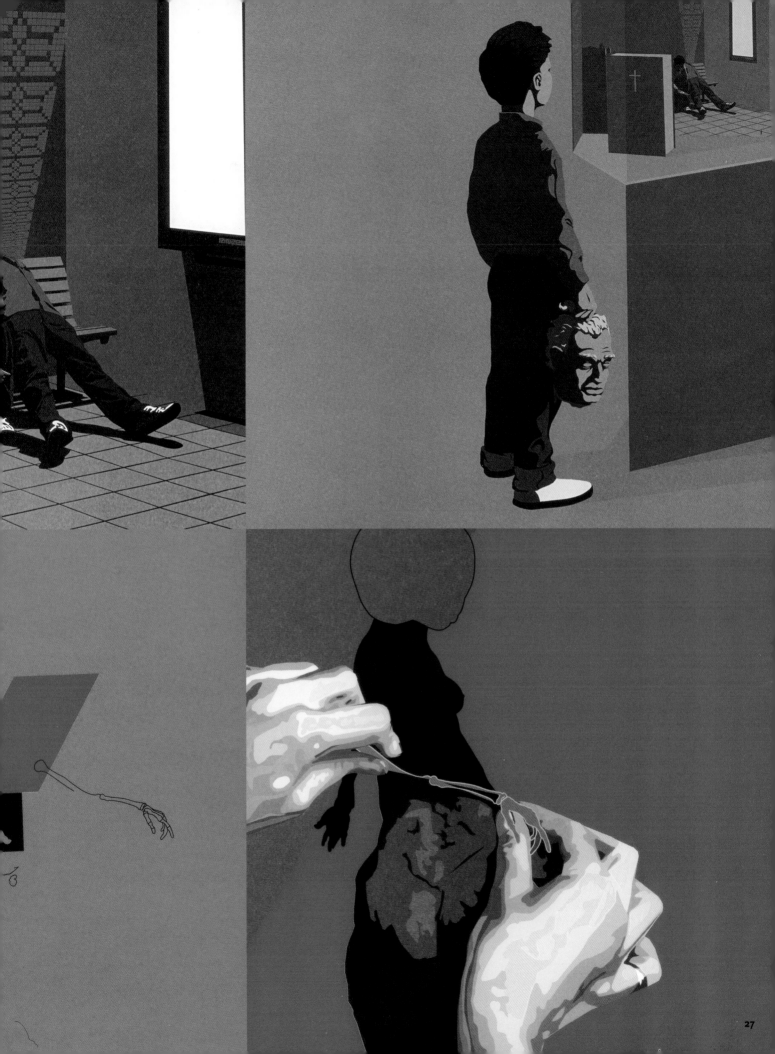

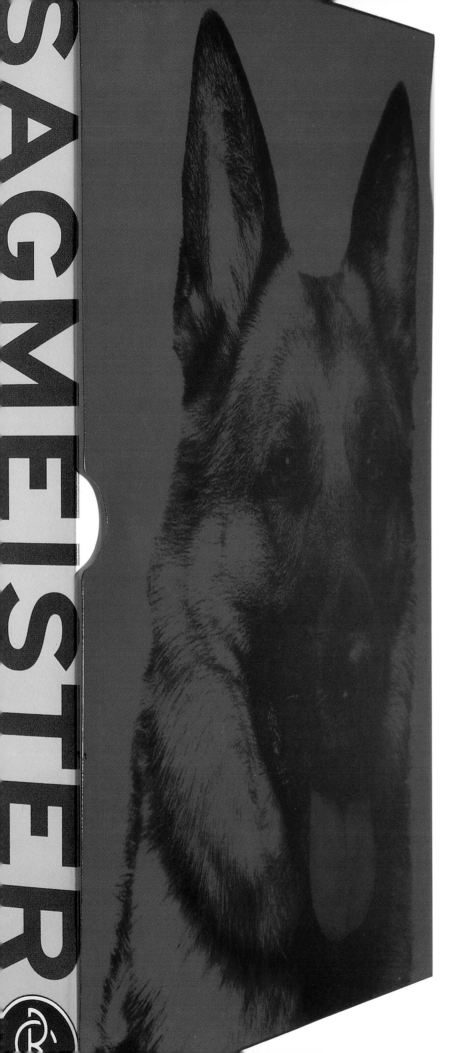

SAGMEISTER

Designers
Stefan Sagmeister,
Hjalti Karlsson

Art Director
Stefan Sagmeister

Photographer
Kevin Knight (cover)

Design Company
Sagmeister Inc.

Country of Origin
USA

Description of Artwork
Paperback book in a
transparent red slipcase
gathering together all of
Sagmeister Inc.'s design
work to date

Dimensions
175 x 245 mm
7 x 9¹/₂ in

Concealed elements are printed on the
leading edge of both sides of each
page. When you hold the book front-
cover up and bend the pages, the
message "Made You Look" appears
along the edge. But if you do the same
thing holding the book back-cover up,
three bones for the dog appear instead
of the original message

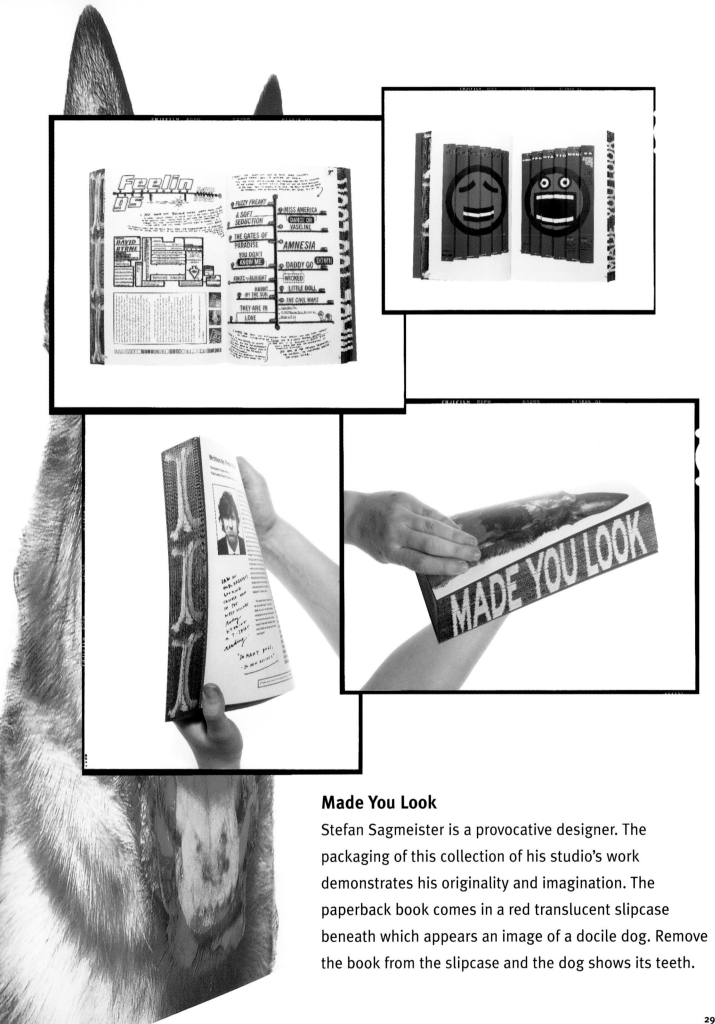

Made You Look

Stefan Sagmeister is a provocative designer. The packaging of this collection of his studio's work demonstrates his originality and imagination. The paperback book comes in a red translucent slipcase beneath which appears an image of a docile dog. Remove the book from the slipcase and the dog shows its teeth.

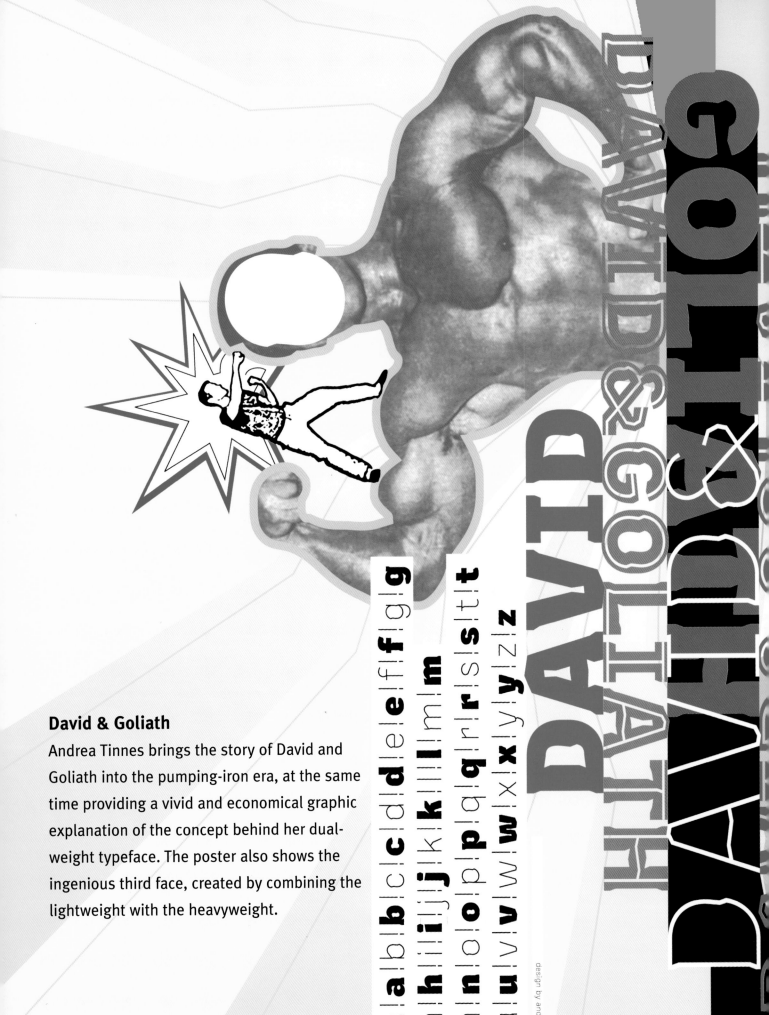

David & Goliath

Andrea Tinnes brings the story of David and
Goliath into the pumping-iron era, at the same
time providing a vivid and economical graphic
explanation of the concept behind her dual-
weight typeface. The poster also shows the
ingenious third face, created by combining the
lightweight with the heavyweight.

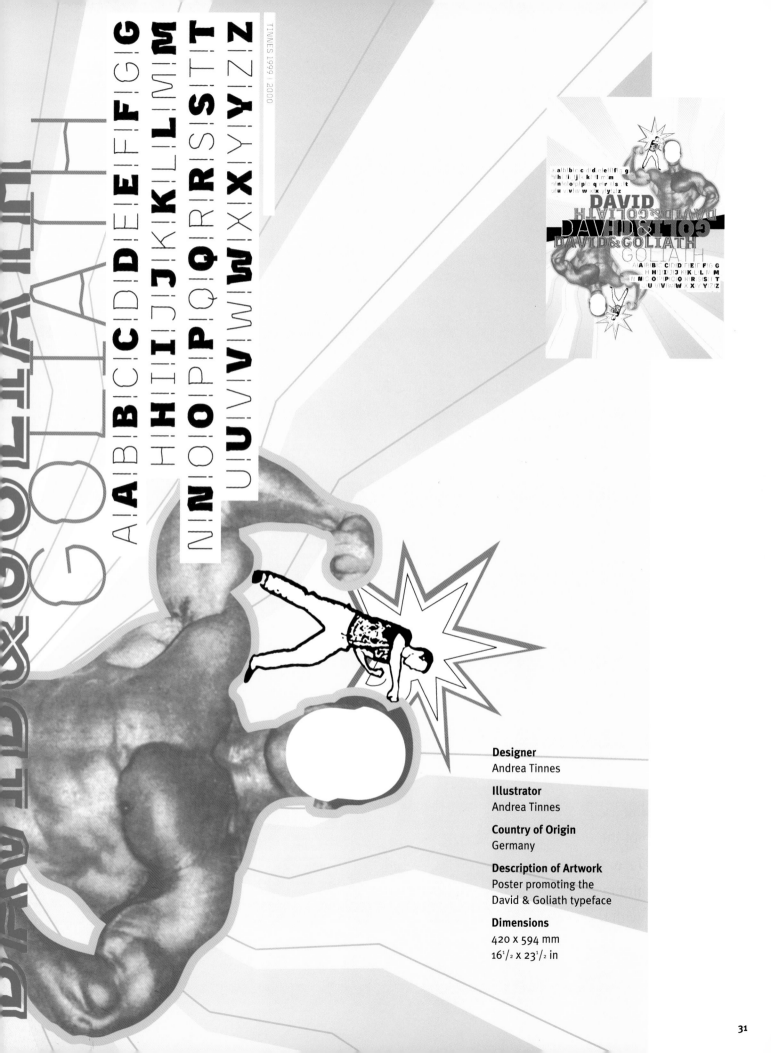

Designer
Andrea Tinnes

Illustrator
Andrea Tinnes

Country of Origin
Germany

Description of Artwork
Poster promoting the
David & Goliath typeface

Dimensions
420 x 594 mm
16½ x 23½ in

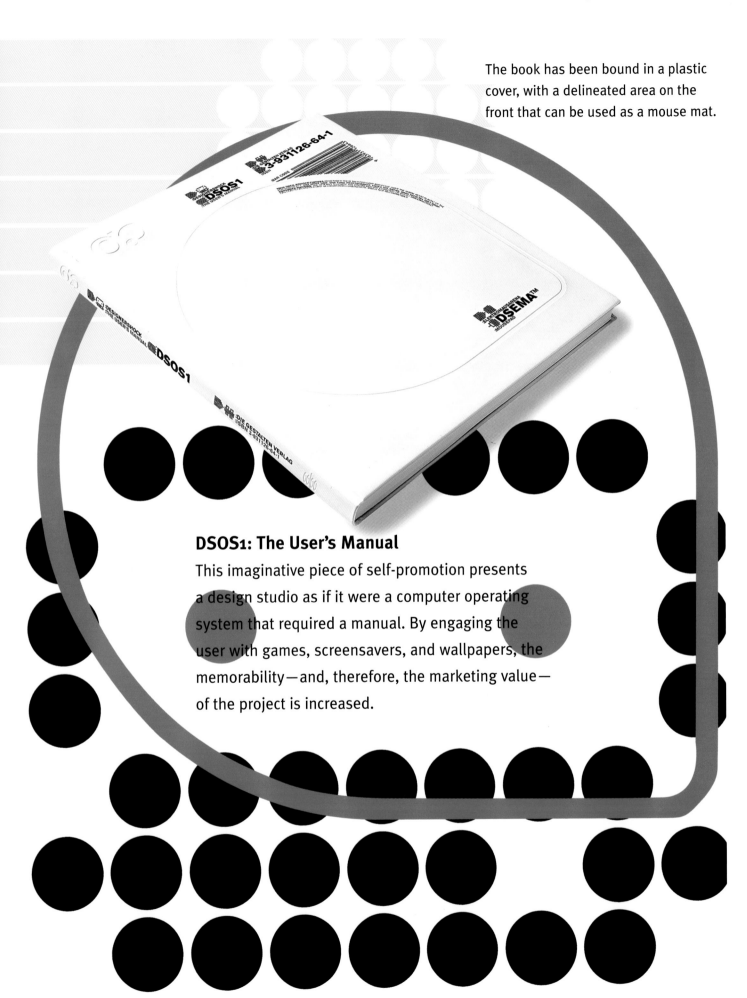

The book has been bound in a plastic cover, with a delineated area on the front that can be used as a mouse mat.

DSOS1: The User's Manual

This imaginative piece of self-promotion presents a design studio as if it were a computer operating system that required a manual. By engaging the user with games, screensavers, and wallpapers, the memorability—and, therefore, the marketing value—of the project is increased.

Designers
Stefan Gandl, Birte Ludwig,
Rob Meek

Art Director
Stefan Gandl

Illustrators
Stefan Gandl, Birte Ludwig,
Rob Meek

Photographers
Stefan Gandl, Birte Ludwig

Design Company
DS (Designershock)

Country of Origin
Germany

Description of Artwork
Book and CD-Rom—a
guide to the Designershock
design group. The CD
provides fonts, games,
and software that allows
access to the online part
of the book.

Dimensions
240 x 280 mm
9¹/₂ x 11 in

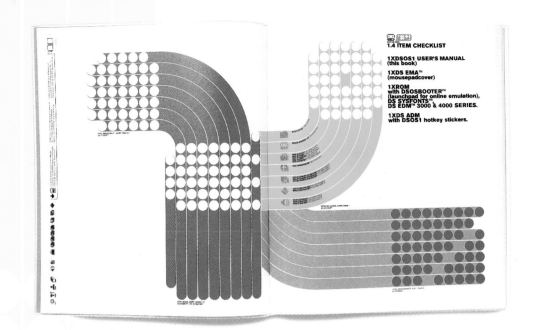

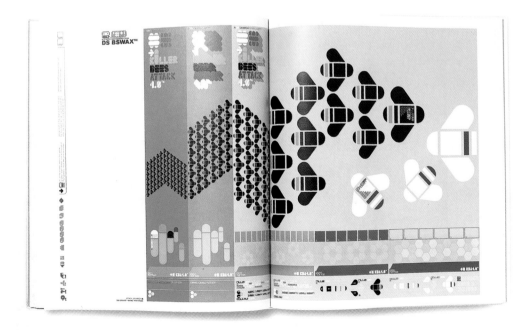

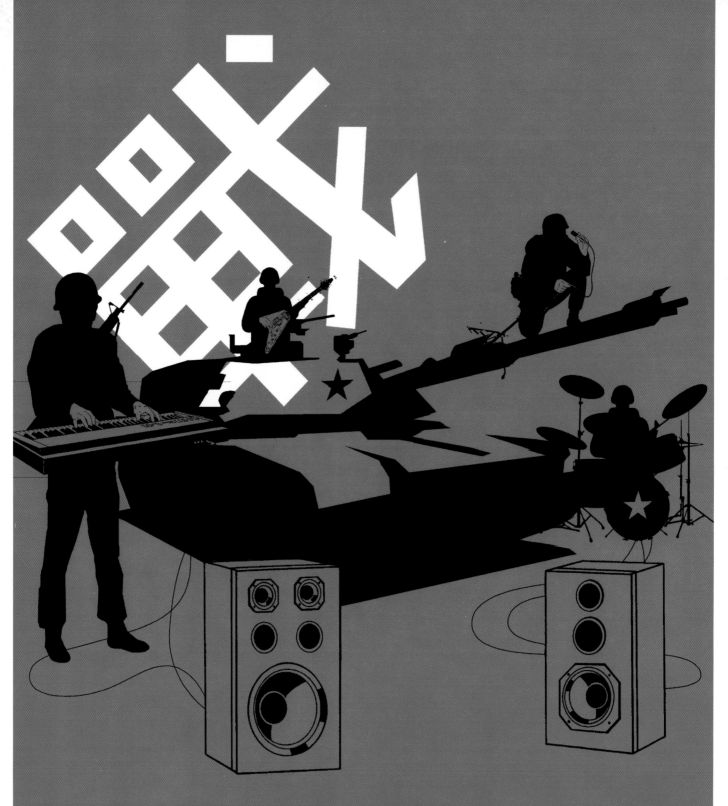

appetite for deconstruction!

beRSeRK!

abcdefghijklmnopqrstuvwxy1234567890

© 2001 Guerilla Fonts Typeface . Berserk! Design . Jackson Tan :phunk Foundry . Guerilla Fonts . 287 River Valley Road Singapore 238 328 Tel . 65 834 9940 Fax . 65 836 9281 www.phunkstudio.com

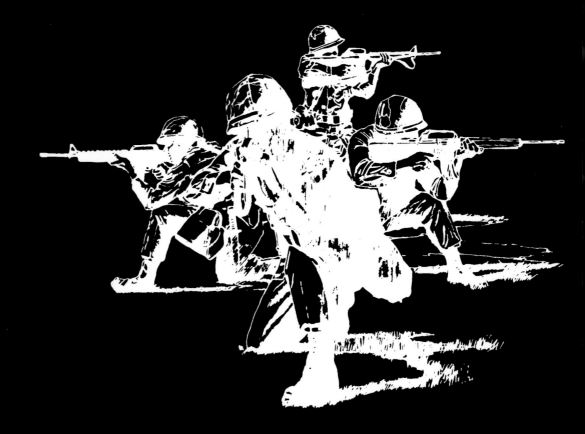

Berserk!

Promoting a typeface presents a singular challenge—that of drawing attention to something that is normally used as a medium rather than a message. Here the designer, perhaps inspired by the name of the typeface, has let his imagination run wild, showing armed soldiers performing rock music on and around a tank. The incongruousness of the scene echoes jarring elements in the typeface design: the eccentricity of the R and the N (referring to the Russian alphabet) in contrast with the S and the T (referring to World War Two German military symbolism).

Designer
Jackson Tan

Illustrator
Jackson Tan

Design Company
:Phunk Studio

Country of Origin
Singapore

Description of Artwork
Designed for the Typecon 2001 exhibition, this poster promotes :Phunk's Berserk! typeface

Dimensions
297 x 420 mm
11³/₄ x 16¹/₂ in

The associations with weaponry and rock music are made verbally as well as visually, with the slogan at the bottom of the poster, which appears to play on the title of the Guns'n'Roses album *Appetite for Destruction*.

DankRealms—Various Projects

Although they are not all part of the same project, the images shown on these two spreads form a unified body of work, which reinforces the identity of the company. Dramatic images of spacecraft, shards of disjointed text, and barely discernible snapshots of suburban Australia are drawn together by the use of violent explosions of color. Even the mundane sight of a car parked behind a postbox (see p.39, bottom right) is made terrifying by the flash of white light engulfing the scene.

(this and following spread)
Designers
Andrew Godfrey, Khan van Grecken, Morten Rowley

Art Directors
Andrew Godfrey,
Khan van Grecken

Photographers
Peter Bainbridge, Andrew Godfrey, Eva Godfrey, outer-space photography captured from the Internet

Design Company
DankRealms

Country of Origin
Australia

Description of Artwork
Excerpts from various projects, including spreads from DankRealms typographic book (DarkSide 01), a poster to advertise www.dankfonts.com, a piece for *Idn* magazine called "Lost in the Fields with Ashleigh," and a submission for :Phunk Studio's Utopia project

Dimensions
Various

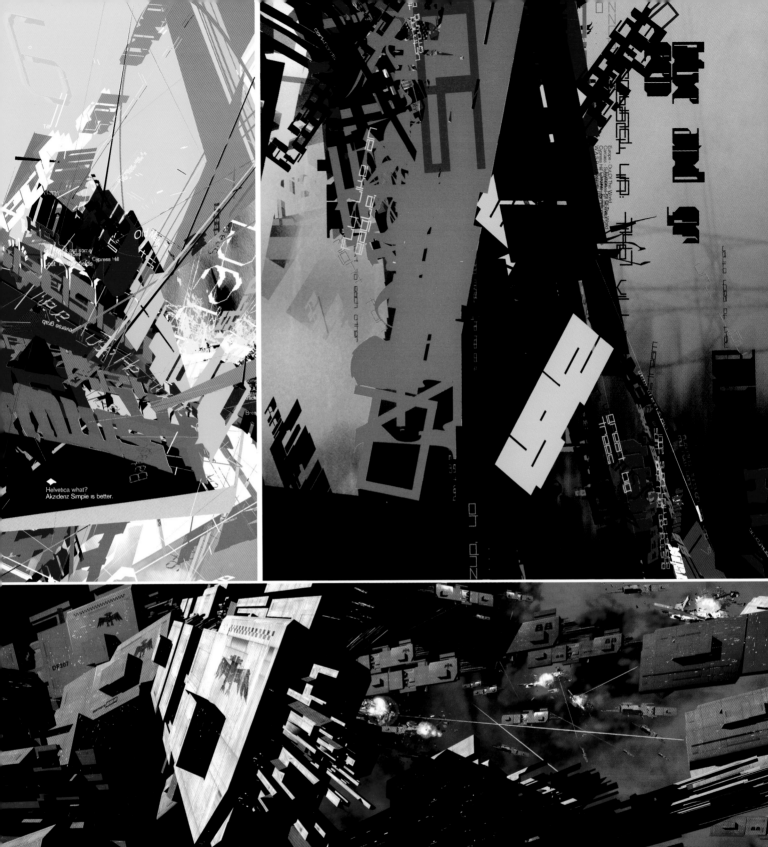
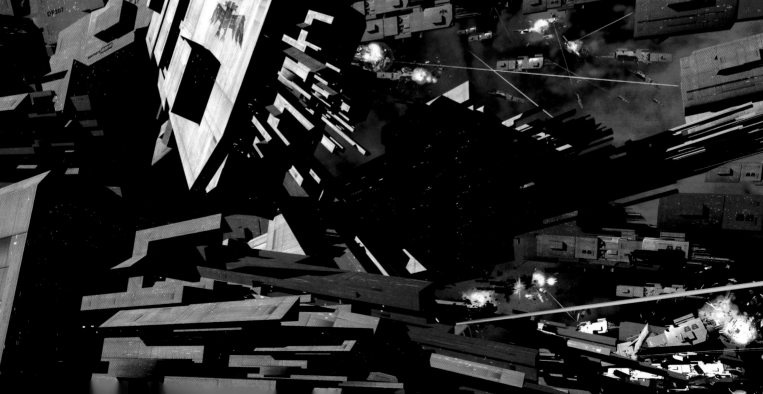

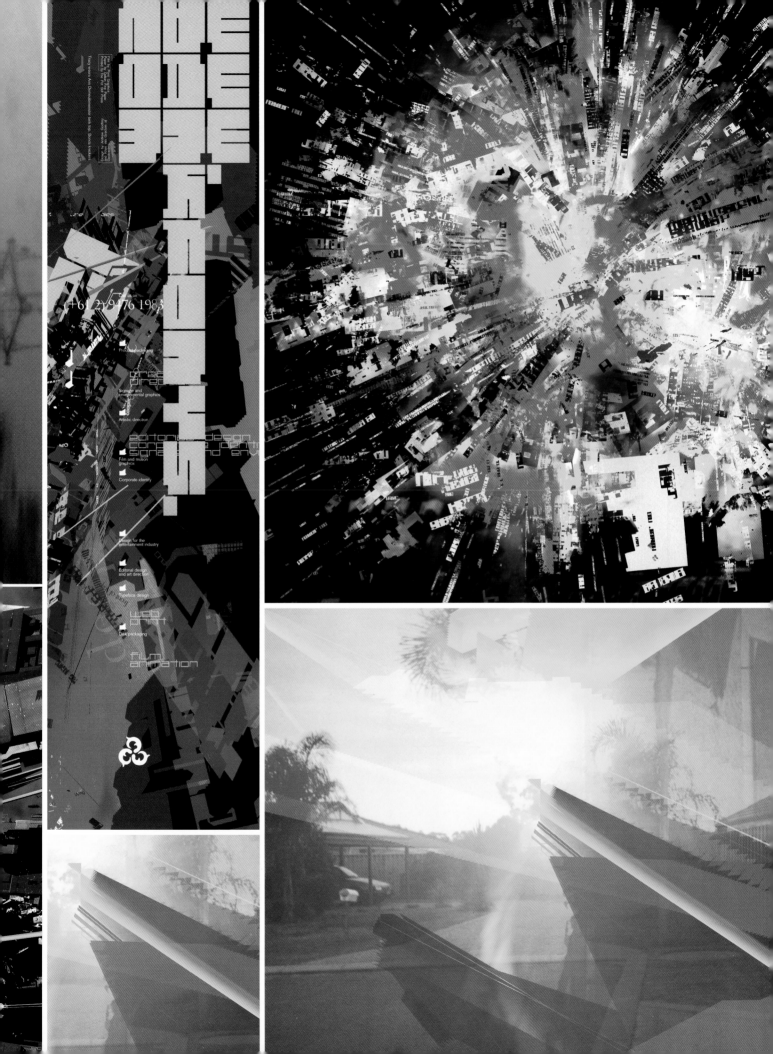

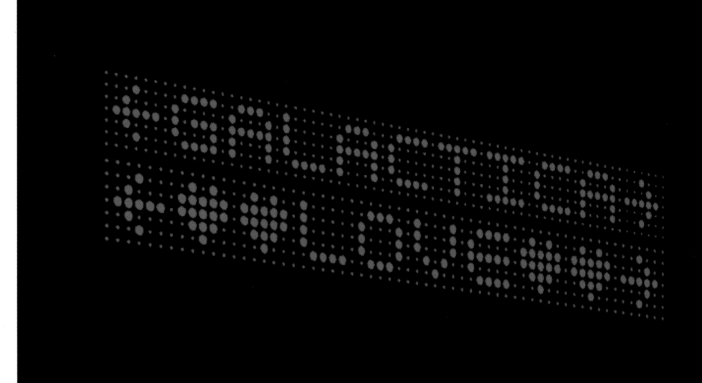

Designer
Alvin Tan

Illustrator
Alvin Tan

Photographer
Alvin Tan

Design Company
:Phunk Studio

Country of Origin
Singapore

Description of Artwork
Poster and "user guide" to promote the Galactica Love typeface at the Typecon 2001 exhibition

Dimensions
Poster: 297 x 420 mm
$11^3/_4$ x $16^1/_2$ in
User guide: 297 x 210 mm
$11^3/_4$ x $8^1/_4$ in

Galactica Love

Replicating the primitive dot-matrix graphics of a
tickertape scoreboard or space invaders console,
this typeface captures the pioneering spirit of 1970s
electronics. The designers have even reserved the
lower case for Atari-style aliens and other symbols,
rather than letters.

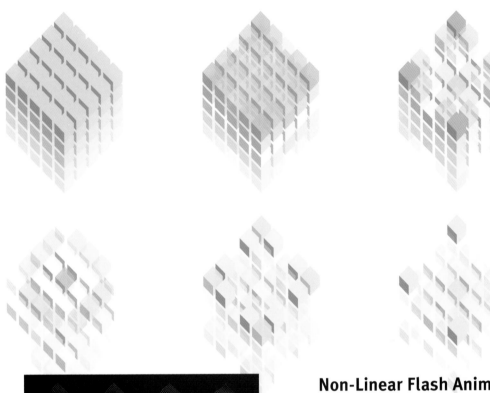

Non-Linear Flash Animations

This self-initiated project from Fluid reveals the members of the studio's passion for mathematics, music, and animation. The gradually mutating abstract patterns change with no external intervention or apparent repetition. Since its non-commercial inception, the project has evolved into a self-promotional screensaver.

Designer
Mark Harris

Design Company
Fluid Design

Country of Origin
UK

Description of Artwork
Computer-generated animated patterns

Dimensions
n/a

Martijn Oostra

Reality

Reality/Digital Hallucination

These two projects both explore the way in which the viewer responds to images. In *Reality* (this page), the iconographic clipart gives an impression of everyday objects, whereas in the road sign the same style of artwork gives an instruction. In *Digital Hallucination* (opposite page), the viewer is seduced into rationalizing an abstract image into a landscape.

reality

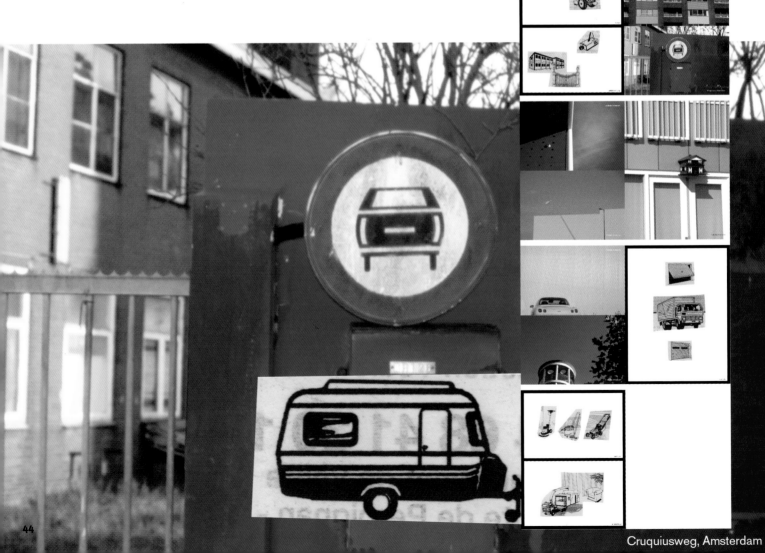

Cruquiusweg, Amsterdam

Designer
Martijn Oostra

Photographer
Martijn Oostra

Country of Origin
The Netherlands

(this page)
Description of Artwork
Photographic essay

Dimensions
245 x 300 mm
9³/₄ x 11³/₄ in

(opposite page)
Description of Artwork
Concept for an article about clipart in architecture (not published in this form). The final version was inserted in Dutch architectural magazines *Archis* and *De Architect*.

Dimensions
245 x 315 mm
9³/₄ x 12¹/₂ in

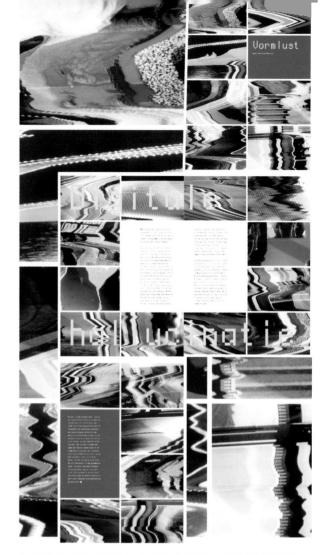

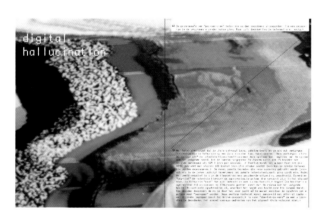

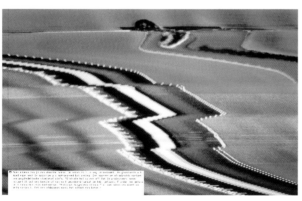

deerde uitzending omgedraaid. Boven-
dien begrijpt de televisie hierdoor de
synchronisatie pulsen die verwerkt
zijn in het signaal niet meer. De tele
visie weet niet wanneer hij een nieuwe
lijn moet beginnen en wanneer hij
linksboven moet beginnen met de opbouw
van het volgende beeld, waardoor het
negatieve beeld over het scherm danst.

De decoder waarvoor je een extra uitge-
breid abonnement moet nemen decodeerd
de gecodeerde kanalen weer naar nor-
maal beeld door het beeld weer positief
te maken waardoor de synchronisatie
pulsen weer begrepen worden, zodat de
programma's uit het Pluspakket bekeken
kunnen worden. Deze analoge techniek
van coderen wordt tegenwoordig aange-
vuld met allerlei geheime digitale
foefjes zodat het bijna onmogelijk is
voor hobbyisten om zelf een uitzending
te decoderen. Het simpel opnieuw
omdraaien van het signaal thuis vol-
staat niet meer.

a heart (unbroken) a heart (unbroken) a heart (unbroken) a broken) a heart (unbroken) a heart (unbroken) a heart

A Heart (Unbroken)

In response to the attack on the World Trade Center, Stefan Sagmeister created this pin that is fashioned from rubble from the site. Proceeds from the sale of the pin go to charity. The heart is a universal symbol understood across political and cultural boundaries. Used in this context the heart evokes both resilience and humanity in the face of great suffering.

Designers
Mathias Ernstberwer,
Martin Iselt,
Stefan Sagmeister

Art Director
Stefan Sagmeister

Illustrator
Martin Iselt

Model Making
Yuji Yoshimoto

Design Company
Sagmeister Inc.

Country of Origin
USA

Description of Artwork
Pin/badge, presentation
case, and accompanying
inlay

Dimensions
Pin: 18 mm, $^3/_4$ in (diameter)
Case: 57 x 57 x 19 mm
$2^1/_4$ x $2^1/_4$ x $^3/_4$ in

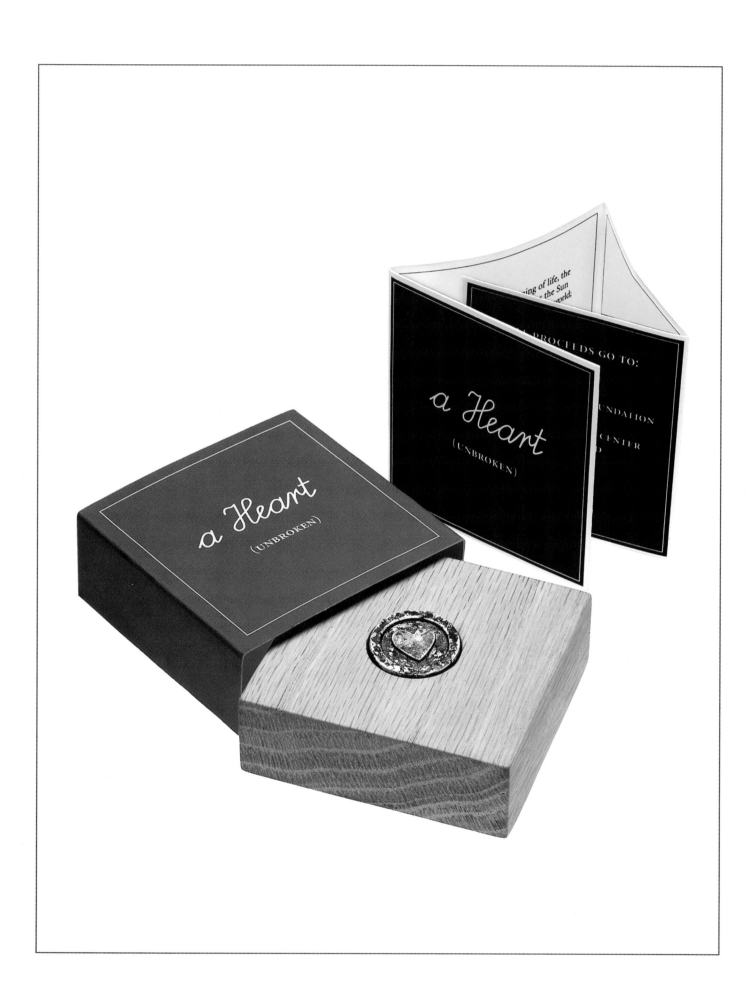

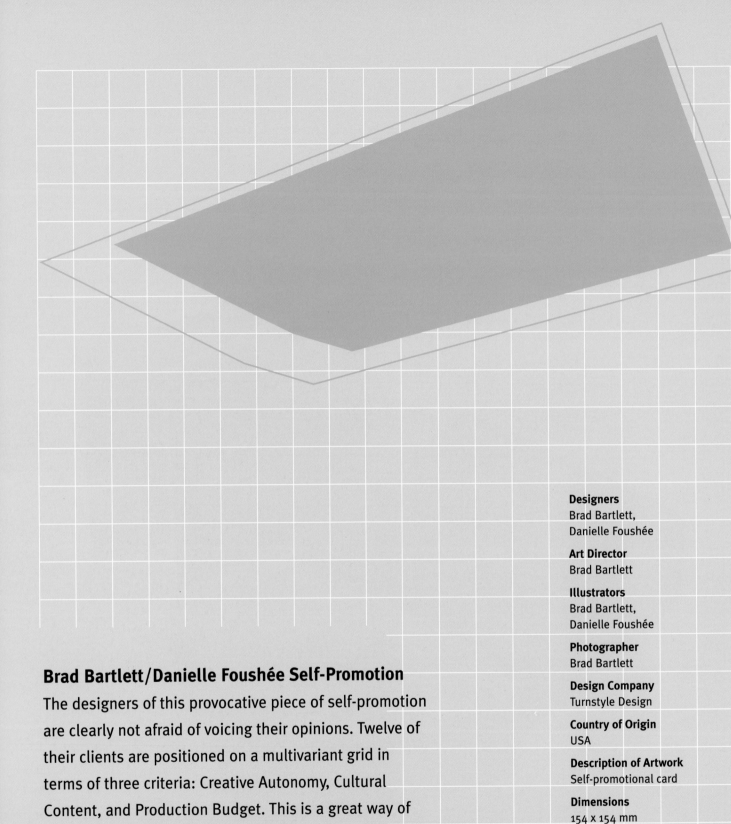

Brad Bartlett/Danielle Foushée Self-Promotion

The designers of this provocative piece of self-promotion
are clearly not afraid of voicing their opinions. Twelve of
their clients are positioned on a multivariant grid in
terms of three criteria: Creative Autonomy, Cultural
Content, and Production Budget. This is a great way of
attracting attention and enables Bartlett and Foushée to
show the breadth of their client base.

Designers
Brad Bartlett,
Danielle Foushée

Art Director
Brad Bartlett

Illustrators
Brad Bartlett,
Danielle Foushée

Photographer
Brad Bartlett

Design Company
Turnstyle Design

Country of Origin
USA

Description of Artwork
Self-promotional card

Dimensions
154 x 154 mm
6 x 6 in

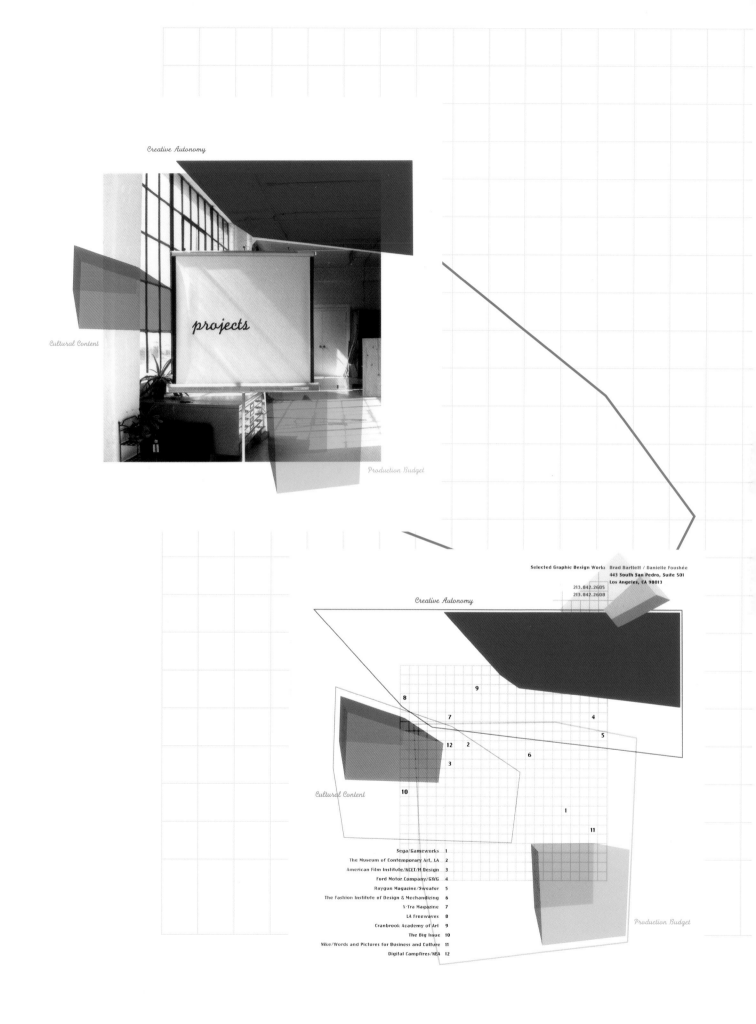

Creative Autonomy

projects

Cultural Content

Production Budget

Selected Graphic Design Work: Brad Bartlett / Danielle Foushée
443 South San Pedro, Suite 501
Los Angeles, CA 90013
213.842.2605
213.842.2608

Creative Autonomy

Cultural Content

Production Budget

Sega/Gameworks	1
The Museum of Contemporary Art, LA	2
American Film Institute/KCET/H Design	3
Ford Motor Company/GWG	4
Raygun Magazine/Sweater	5
The Fashion Institute of Design & Mechandizing	6
X-Tra Magazine	7
LA Freewaves	8
Cranbrook Academy of Art	9
The Big Issue	10
Nike/Words and Pictures for Business and Culture	11
Digital Campfires/NEA	12

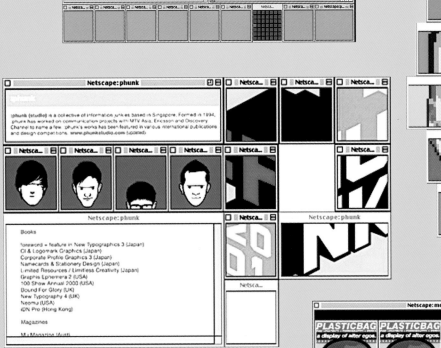

:phunk (studio) is a collective of information junkies based in Singapore. Formed in 1994, :phunk has worked on communication projects with MTV Asia, Ericsson and Discovery Channel to name a few. :phunk's works has been featured in various international publications and design competitions. www.phunkstudio.com (updated)

Books

foreword + feature in New Typographics 3 (Japan)
CI & Logomark Graphics (Japan)
Corporate Profile Graphics 3 (Japan)
Namecards & Stationery Design (Japan)
Limited Resources / Limitless Creativity (Japan)
Graphis Ephemera 2 (USA)
100 Show Annual 2000 (USA)
(s)ound For Glory (UK)
New Typography 4 (UK)
Neomu (USA)
iDN Pro (Hong Kong)

Magazines

M+ Magazine (Aust)

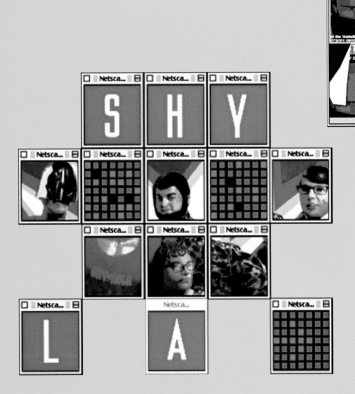

PHIZ
dingbats illustrations.

© 2001 Guerilla Fonts

PHIZ gear.

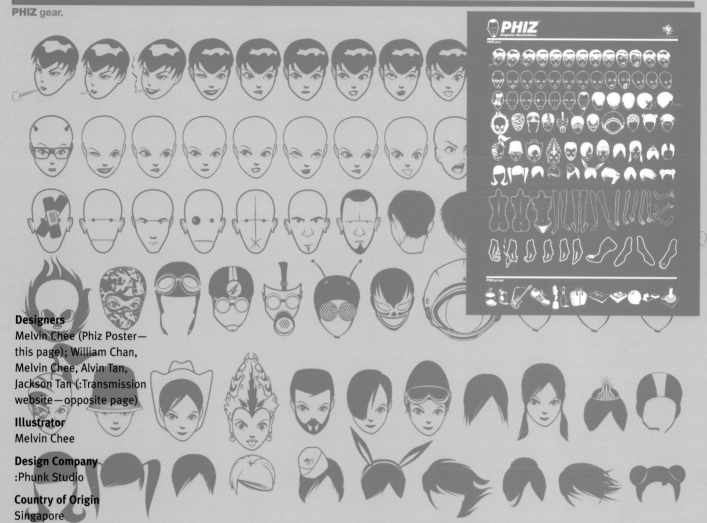

Designers
Melvin Chee (Phiz Poster—
this page); William Chan,
Melvin Chee, Alvin Tan,
Jackson Tan (:Transmission
website—opposite page)

Illustrator
Melvin Chee

Design Company
:Phunk Studio

Country of Origin
Singapore

(this page)
Description of Artwork
Poster designed for the
Typecon 2001 exhibition to
promote the Phiz Dingbat
and to introduce the
"plastic" characters
designed by :Phunk

Dimensions
297 x 420 mm
11³/₄ x 16¹/₂ in

(opposite page)
Description of Artwork
Experimental bi-monthly
e-zine on design

Dimensions
n/a

Phiz Poster/:Transmission Website

:Phunk's poster to promote their Phiz Dingbats
illustrations (this page) is strongly influenced by the
style of illustration developed for dry transfers in the
1960s—the layout and color of the poster even
resembles a sheet of dry transfers.

The :Transmission website created by :Phunk
(opposite page) serves as a magazine, gallery, and
design debate forum, as well as a contact point for
the studio itself.

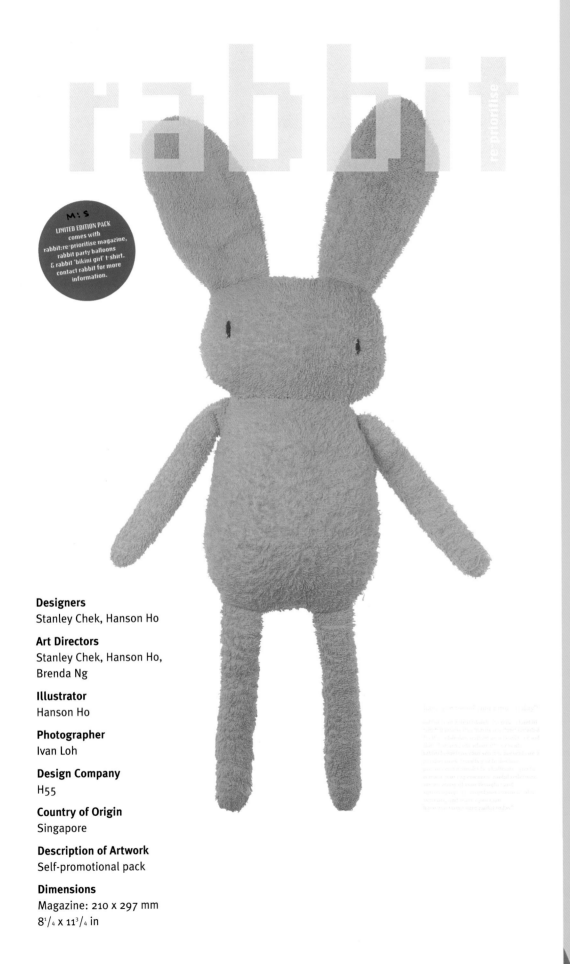

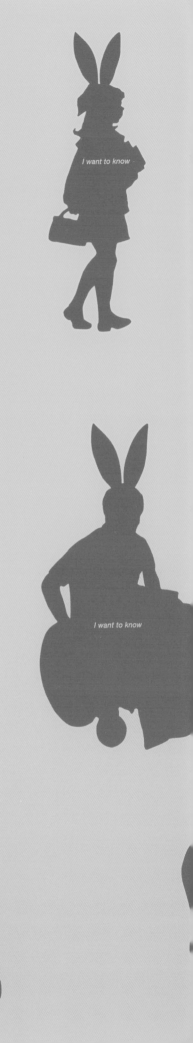

rabbit

re-prioritise

M:S
LIMITED EDITION PACK
comes with
rabbit:re-prioritise magazine,
rabbit party balloons
& rabbit 'bikini girl' t-shirt.
contact rabbit for more
information.

I want to know

I want to know

Designers
Stanley Chek, Hanson Ho

Art Directors
Stanley Chek, Hanson Ho,
Brenda Ng

Illustrator
Hanson Ho

Photographer
Ivan Loh

Design Company
H55

Country of Origin
Singapore

Description of Artwork
Self-promotional pack

Dimensions
Magazine: 210 x 297 mm
8$^1/_4$ x 11$^3/_4$ in

rose, we would like to print the 'sexy bikini girl' image on the front of the t-shirt, and have the ugly carrot logo on the back. thanks!

f: hanson +65 7337 595

Rabbit

Created by design studio H55, this self-promotional pack includes a magazine, T-shirt, and some party balloons. The notion of the package is that the contents stimulate the user to reevaluate and reprioritize elements of his or her life. To this end design conventions are questioned— for example, the label on the blank T-shirt carries instructions as to what should be printed on the front and back of it. This, along with other design elements such as a double-page spread of quirky red silhouettes, each with the phrase "I want to know" reversed out of the figure, serves to intrigue the viewer and thus promote the studio.

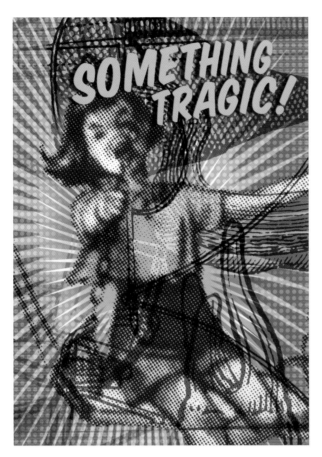

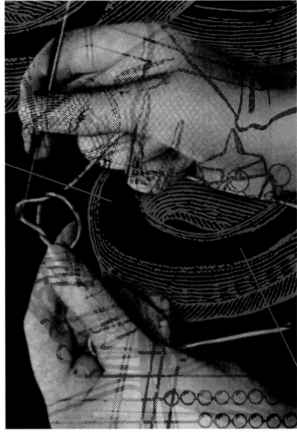

Abacus

In this book we are invited to form our own big ideas, by making associations between diverse elements such as fragments of text, graphic imagery, and found objects. As the title suggests, the book provides a framework, and the reader has to make things add up. The result is a work of art as fluid and interactive as the most sophisticated computer application.

Designer
Elizabeth Roberts

Country of Origin
Germany

Description of Artwork
A "prose-picture" book for adults printed in 5-color offset leoporello

Dimensions
100 x 150 mm
4 x 6 in

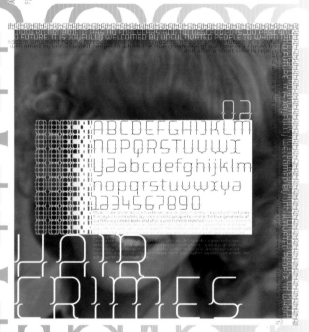

01

ABCDEFGHIJKLMNO
PQRSTUVWXYZabcd
efghijklmnopqrstuv
wxyz 1234567890

HAIR
CRIMES

02

ABCDEFGHIJKLM
NOPQRSTUVWXY
Zabcdefghijklm
nopqrstuvwxya
1234567890

HAIR
CRIMES

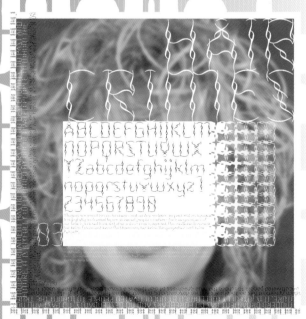

HAIR
CRIMES

ABCDEFGHIJKLM
NOPQRSTUVWX
YZabcdefghijklm
nopqrstuvwxyz1
234567890

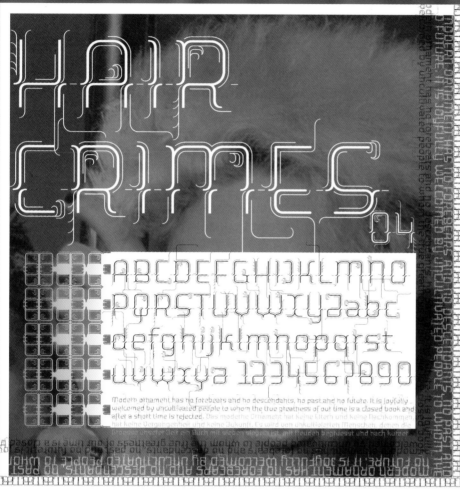

Hair Crimes

The individual posters used to promote these four typefaces are given a strong collective identity by the use of various visual links, such as: the presentation of the typeface in a white block covering the face; the appearance of text along two edges of the poster; the positioning of the name Hair Crimes in a different corner on each poster; and the complementary monochrome tones of the images. Perhaps the posters are so satisfying as a series because these subtle design elements are not immediately apparent.

Designer
Andrea Tinnes

Photographer
Andrea Tinnes

Country of Origin
Germany

Description of Artwork
Four posters displaying Hair Crimes, a series of ornamental typefaces

Dimensions
457 x 457 mm
18 x 18 in

Das moderne Ornament
hat keine Eltern und keine Nachkommen, hat keine Vergangenheit und keine Zukunft. Es wird von unkultivierten Menschen, denen die Groesse unserer Zeit ein Buch mit sieben siegeln ist, mit freuden begruesst und nach kurzer Zeit verleugnet.

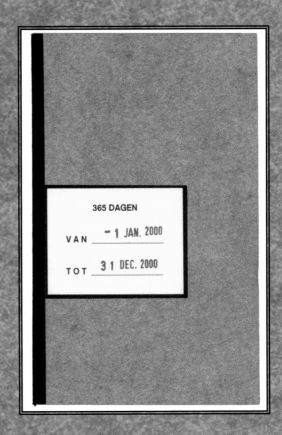

365 Dagen (365 Days)

At once a practical item and a wry comment on the way we record our lives, this is an elegant response to the inflexible tyranny of conventional diaries. The days have been printed without dates, which the user has to fill in, enabling him or her to start and stop making entries at will. Thus, it eliminates the guilt associated with leaving long stretches of blank pages where we have nothing we wish to record—perhaps during school vacations. Or during the semesters.

The designer suggests using a stamp to fill in the missing dates, as in the example (right).

- 3 JAN. 2000	MAANDAG		DONDERDAG	- 6 JAN. 2000
- 4 JAN. 2000	DINSDAG		VRIJDAG	- 7 JAN. 2000
- 5 JAN. 2000	WOENSDAG		ZATERDAG	- 8 JAN. 2000
			ZONDAG	- 9 JAN.

Designer
Martijn Oostra

Country of Origin
The Netherlands

Description of Artwork
Diary

Dimensions
105 x 165 mm
4 x 6¹/₂ in

	MAANDAG		DONDERDAG	
	DINSDAG		VRIJDAG	
	WOENSDAG		ZATERDAG	
			ZONDAG	

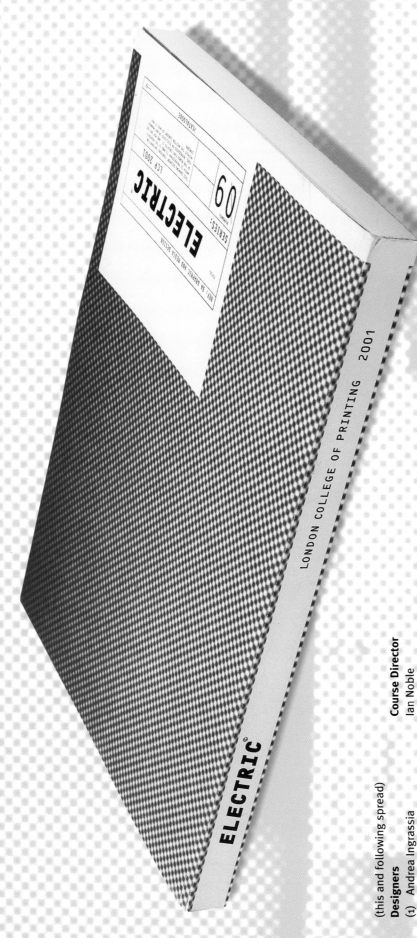

Electric

The title of this degree book suggests high energy and the potential to shock, as well as referring to the power source for the graphic designer's most commonly used tool—the computer. The publication works on a number of levels: as a showcase for students' work, as a challenge to preconceptions about the study and practice of graphic design, and as a means of promoting the course itself.

Course Director
Ian Noble

Art College
London College of Printing

Country of Origin
UK

Description of Artwork
Catalog of work by LCP graphic and media design students, class of 2001

Dimensions
208 x 265 mm
$8^{1}/_{4}$ x $10^{1}/_{2}$ in

(this and following spread)
Designers
(1) Andrea Ingrassia
(2) Angelica Aliling
(3) Jennifer Lai
(4) Marcus Tonndorf
(5) Mukhsin Hanifiah
(6) Marcus Hewitt
(7) Joanne Oli
(8) Ian Tyler
(9) Christian Graham
(10) Jake Zoltan Headley
(11) Gori Ogunyemi
(12) Justine Gray
(13) Natalie Hay
(14) Larisa Blackwood
(15) Susannah Epstein
(16) Christine Smith

ANGELICA ALILING 79

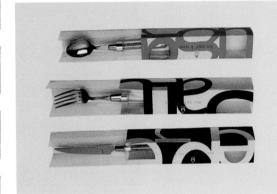

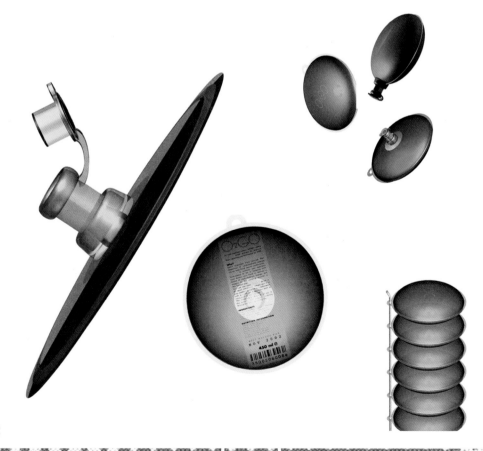

INSPI

PERSP

78 ANDREA INGRASSIA

(5)

ELEMENT: EXPERIMENTAL TYPOGRAPHY / TYPOGRAPHY	DATE: 06-01	
DATABASE: SPUDDDLCP	W:12.5	Y:82.5
TESTSPECS1: 6	C:77.5	K:25.0

MEHRDIN MAARTINA 63

(6)

CHRISTIAN JUNKER 60

(8)

GLASTONBURY 2001 home

Welcome to Glastonbury Festival 2001. The site consists of five option areas – Info, Tickets, Webcast, Recreation and Search. These areas can be reached via the image below or the corresponding menu to the left. Roll over an image or menu option to find out more detail about its contents.

info
tickets
webcast
recreation
search

JOHANNE ELLI 73

(4)

aulc

sleepwalker

MARCUS TENNANT 128

JENNIFER LAI 128

(7)

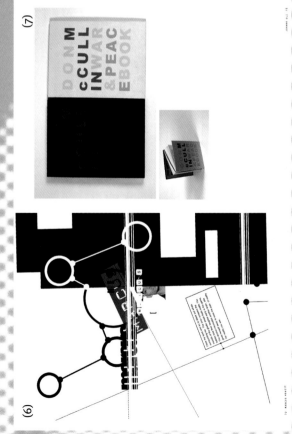

DONM
cCULL
INWAR
&PEAC
EBOOK

DONM
cCULL
IN

(3)

MARCUS MAATIS 72

Stitch-Me

The cross-stitch basis for the design of this typeface is underlined by visual prompts in the poster, such as the needle and thread and the graphic representation of the perforated material used as a base for tapestry. The sewing machine in the background hints at a more mechanized approach—perhaps a metaphor for the computer.

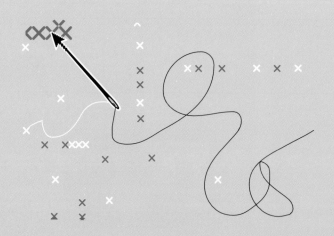

Designer
Andrea Tinnes

Photographer
Andrea Tinnes

Country of Origin
Germany

Description of Artwork
Poster displaying the typeface Stitch-Me

Dimensions
420 x 594 mm
16$^{1}/_{2}$ x 23$^{1}/_{2}$ in

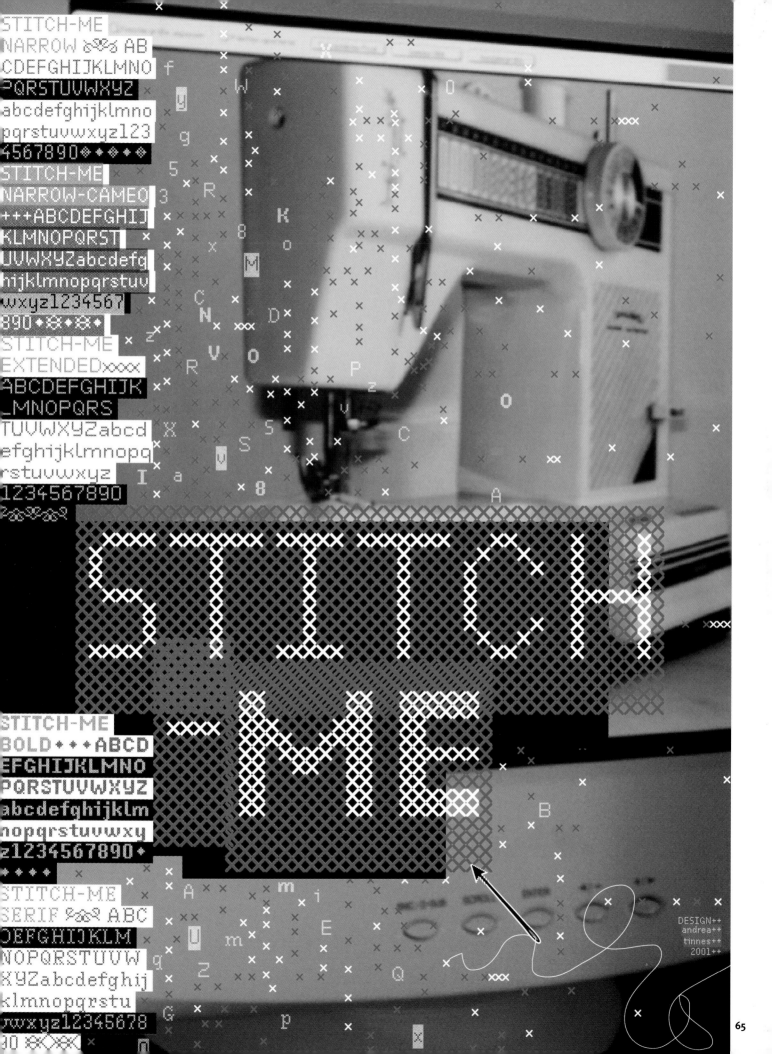

STITCH-ME
NARROW &∞ AB
CDEFGHIJKLMNO
PQRSTUVWXYZ
abcdefghijklmno
pqrstuvwxyz123
4567890◆■◆❖■
STITCH-ME
NARROW-CAMEO
+++ABCDEFGHIJ
KLMNOPQRST
UVWXYZabcdefg
hijklmnopqrstuv
wxyz1234567
890◆❖◆❖◆
STITCH-ME
EXTENDEDxxxx
ABCDEFGHIJK
LMNOPQRS
TUVWXYZabcd
efghijklmnopq
rstuvwxyz
1234567890
❀❀❀❀❀❀

STITCH-ME
BOLD◆◆◆ABCD
EFGHIJKLMNO
PQRSTUVWXYZ
abcdefghijklm
nopqrstuvwxy
z1234567890◆
◆◆◆

STITCH-ME
SERIF ∞∞ ABC
DEFGHIJKLM
NOPQRSTUVW
XYZabcdefghij
klmnopqrstu
vwxyz12345678
90 ∞∞∞∞

DESIGN++
andrea++
tinnes++
2001++

65

section **1234567890**

ideas for them

Designers
Stefan Sagmeister,
Hjalti Karlsson

Art Director
Stefan Sagmeister

Design Company
Sagmeister Inc.

Country of Origin
USA

Description of Artwork
T-shirts, pin, mug, and
inflatable sculptures to
support the "Move our
Money" campaign—an
initiative by Ben Cohen
(of Ben & Jerry's ice cream
fame) to press for the
shifting of 15% of US public
spending on defense to
education and healthcare

Dimensions
Various

Move Our Money

Appropriately for a clearly defined, single-issue
campaign, the materials designed to publicize it feature
stripped-down graphics that highlight the enormity of
the Pentagon budget. Some of the charts, such as the
ones on the mug, are self-explanatory, whereas the pie-
chart on the badge is left unlabeled, a ploy to intrigue
people into asking the badge's wearer what it represents.
The huge inflatable sculptures form part of a traveling
road show.

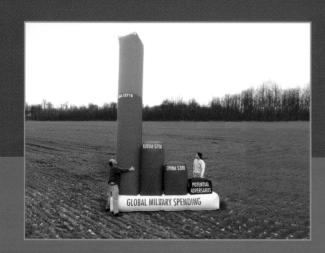

GLOBAL MILITARY SPENDING

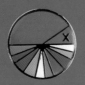

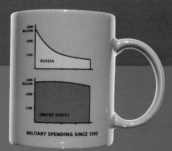

MILITARY SPENDING SINCE 1990

FRONT OF STORE : SHOPPING BASKETS

Here are a few dates to help your shopping experience.
NOW - early bird delegate registration open
AUGUST 1 - closing date for entries
EARLY OCTOBER - nominations will be published
NOVEMBER 2-3 - conference takes place

FOR MORE INFORMATION GO TO
WWW.PROMAX-UK.ORG/2001

Our buyers are travelling the world to
secure keynote speakers of the highest
quality. Our assembly team have begun
work on a fleet of sessions built from
the finest materials. We guarantee the
freshest conference in years. We will
post developments on our website as
they happen and this year we're
paperless for entries.

So click on www.promax-uk.org/2001
for details such as:

· Headline news of keynote speakers
· Up to date information on sessions
· Entry forms
· Price lists
· Technical Specs
· Accommodation information
· A unique time line to help you plan

Designer
Matthew Kerr

Art Director
Gush Mundae

Design Company
Bulletproof Design

Country of Origin
UK

Description of Artwork
Literature and branding
scheme for a creative media
and marketing awards
ceremony and conference

Dimensions
Various

Promax-UK 2001 Conference and Awards

Recognizing that the contemporary TV landscape is a
"crowded marketplace," the designer has taken this
description literally, likening the multitude of television
channels competing for our attention to branded goods
stacked in a supermarket, "each one claiming to be
better than its competitor." The analogy has been carried
through with scrupulous and loving attention to detail—
see the aisle of TV stations as breakfast cereals.

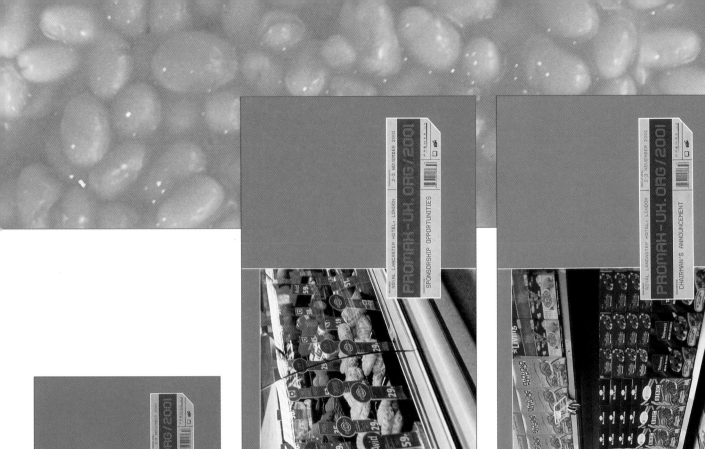

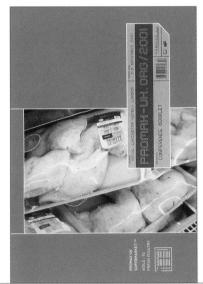

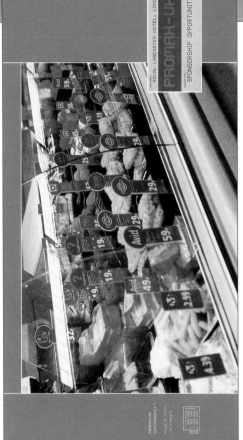

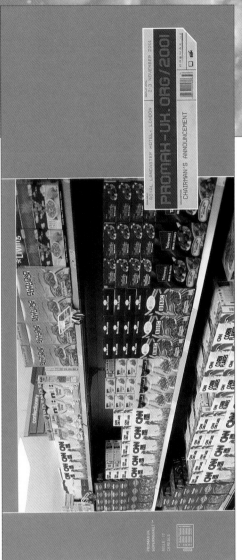

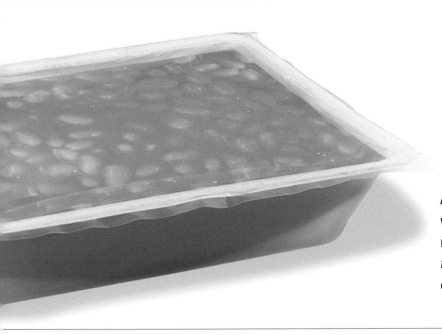

All the mailshots for this conference were sent out in the style of microwaveable packaging, with a *trompe l' oeil* image of baked beans on the plastic lid.

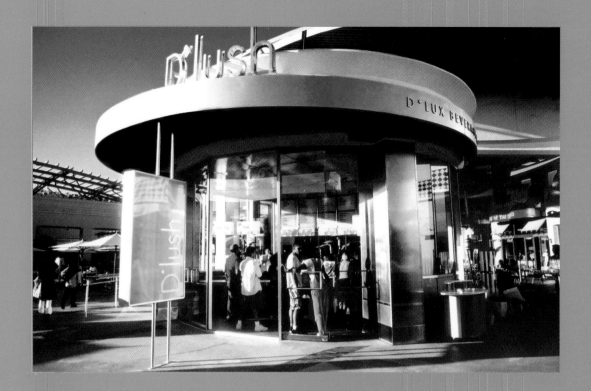

Designers
Guusje Bendeler, Mark
Boydston, Pam Meierding,
Kacy Philips

Art Director
Don Hollis

Design Company
Hollis Design

Country of Origin
USA

Description of Artwork
Identity system (including
signage program) and
branding campaign

Dimensions
Various

D'lush—D'lux Beverage Joint

The design of this "beverage joint" needs to be strong enough to be perennial, but flexible enough to accommodate seasonal menu variations. Clean, modern typography and stainless steel provide the backdrop for the visual presentation of the products on sale at any given time. By adopting a unified approach to type style, color, and imagery, the designers succeed in establishing a strong brand identity.

Give Pleasure — Share the Love with D'lush Gift Certificates

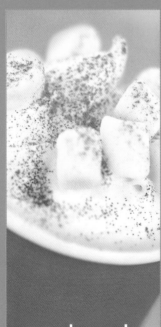
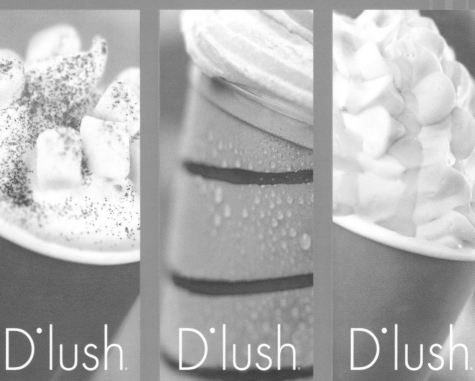

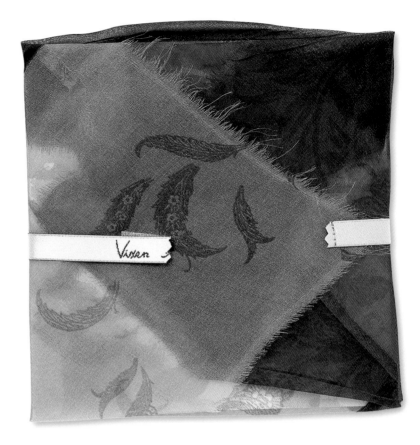

Designer
Stephen Banham

Photographers
Virginia Cummings,
Robyn Lea

Design Company
The Letterbox

Country of Origin
Australia

Description of Artwork
Hand-assembled catalog for
Vixen, a clothing company

Dimensions
145 x 145 mm
5³/₄ x 5³/₄ in

Vixen

Promotional literature does not have to rely solely
on words and images to convey the values of the
organization it advertises. This catalog was screen-
printed, hand-assembled, and individually wrapped,
making each copy unique. This mirrors Vixen's strong
belief in producing clothes by hand and delighting in
the consequent variations from piece to piece.

THE FIXED NATURE OF VIXEN'S SARONGS, and the mutations they undergo, provide rhythm in this way. Each is transformed from rectangle to scarf, to rectangle to skirt, to rectangle to throw, in a rhythmic interchange and variation. It is misleading, however, to say that the sarong itself is always the constant. Like repetition itself, Vixen's sarongs are both fixed and changeable. Whilst the basic premise of the rectangle is maintained throughout, what happens on the surface of each individual work is open to variation. So, although the sarong may appear to be fixed in terms of its form, the patterning printed upon it varies considerably from piece to piece. This is not only a virtue of the design, but also the result of their commitment to the handworking process.

PRINTING BY HAND *and often working back into the pieces once they*
are printed, *means that each length of fabric is unique.*

This works directly against the precision of mass production techniques, where such variation is seen as a flaw, and flawed fabric becomes 'seconds'. Instead of discarding the flaw, Vixen celebrate it, as recognition of their intimate association with the cloth.

14 15

THUS, WHERE THE SURFACE OF THE FABRIC MAY
WELL BE COVERED WITH ORDERED PATTERN
(LIKE DELEUZE AND GUATTARI'S METER), THROUGH OVERPAINTING
AND THE MARKS RESULTING FROM THE
HANDPRINTING PROCESS, VIXEN SUBVERT
THIS REGULARITY, EXPOSING IT TO ALTERATION.

THIS IS ANOTHER WAY IN WHICH THEIR WORK
IS RHYTHMIC: RATHER THAN PRESENTING TWO
ISOLATED POLARITIES (NIGHT/DAY, OPEN/SHUT, PATTERN/SPACE)
THEY REVEAL THE SLIPPAGE AND MOVEMENT
THAT EXISTS BETWEEN OPPOSITIONS, THE SEAM
AT WHICH THEY JOIN.

18

19

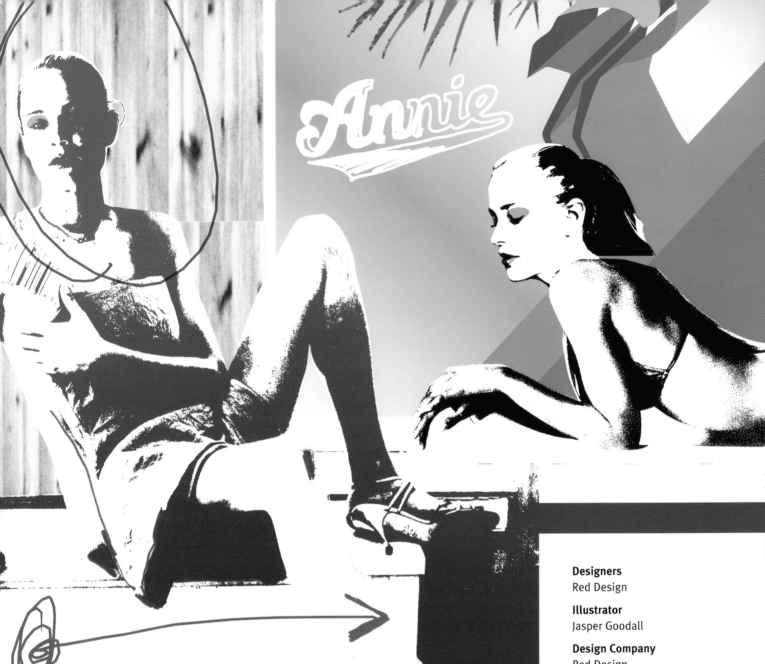

Annie

The all-night parties held in late-1960s New York bathhouses, reminiscent of the scenes shown on these covers, were a forerunner of the disco scene. By dropping pictures of the contemporary dance music artist Annie into these steamy settings, the designers subtly pay homage to disco music, which forms the basis for the samples in Annie's work.

Designers
Red Design

Illustrator
Jasper Goodall

Design Company
Red Design

Country of Origin
UK

Description of Artwork
Record and CD cover designs for Annie's *The Greatest Hit* and *The Greatest Dubs*

Dimensions
Record: 305 x 305 mm
12 x 12 in
CD: 140 x 120 mm
5$^{1}/_{2}$ x 4$^{3}/_{4}$ in

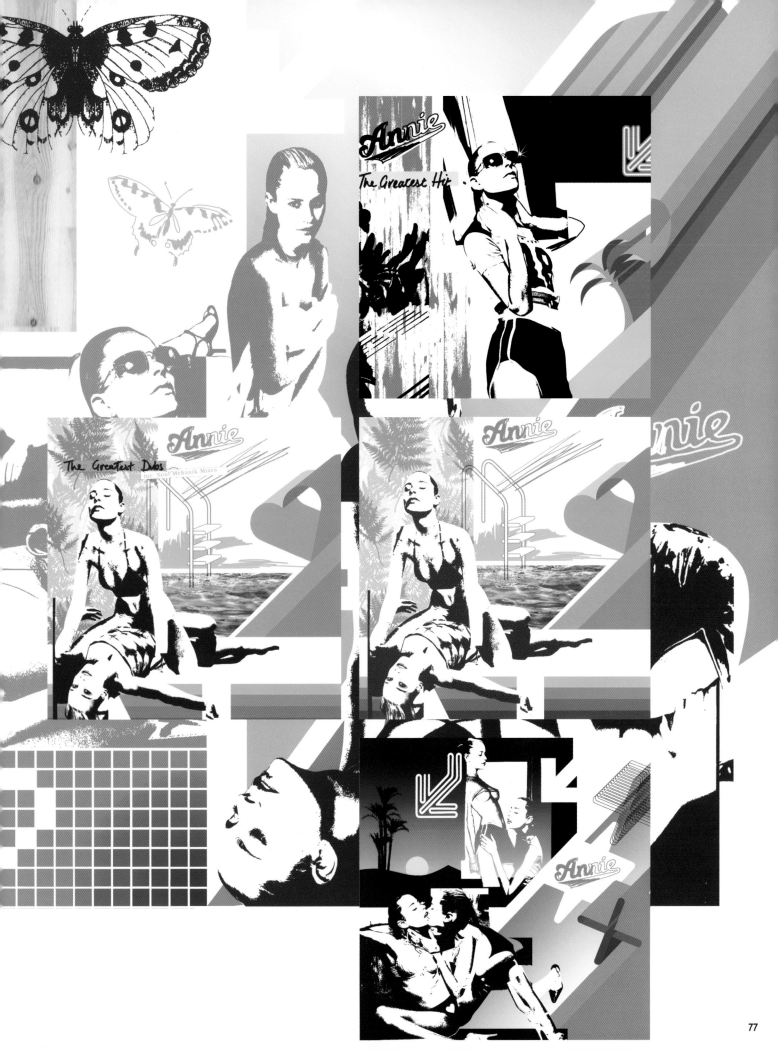

Spaced Out

This exhibition catalog is bound uncompromisingly in printers' make-ready sheets, where type and imagery collide randomly—reinforcing the central themes of impermanence and rapid, ungoverned change. The logo-type on the postcard (opposite page, bottom inset) is reminiscent of 1950s science-fiction comics and movie posters, adding to the surreal effect of the image of a yet-to-be-built neighborhood.

SPACEDOUT: SOUTHERNCALIFORNIAVI

An exhibition of works about social space in S

SPA

rn·california·vern

Designer
Paul Drohan

Art Director
Don Hollis

Design Company
Hollis Design

Country of Origin
USA

Description of Artwork
Poster, postcard, and
catalog for a gallery
exhibition

Dimensions
Poster: 415 x 260 mm
16¼ x 10¼ in
Postcard: 150 x 115 mm
6 x 4½ in
Catalog: 140 x 215 mm
5½ x 8½ in

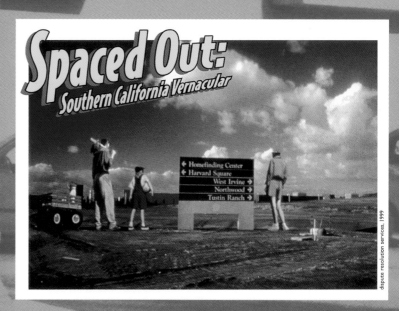

(this and following spread)
Designer
Dr. Pêche (Doktor Pêche)

Photographer
Mademoiselle Rose

Design Company
Laboratoires CCCP

Country of Origin
France

Description of Artwork
Series of posters for the
2000–2001 program of
events at the Centre
Dramatique National
d'Orléans in France

Dimensions
Each poster printed in two
sizes: 400 x 600 mm
15^3/$_4$ x 23^1/$_2$ in; and
1200 x 1750 mm
47^1/$_4$ x 69 in

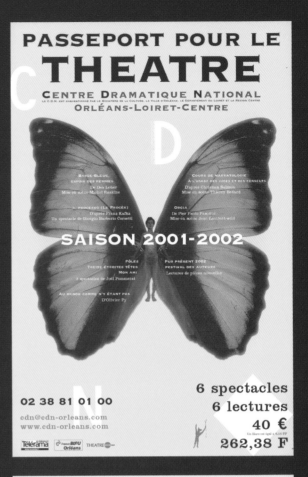

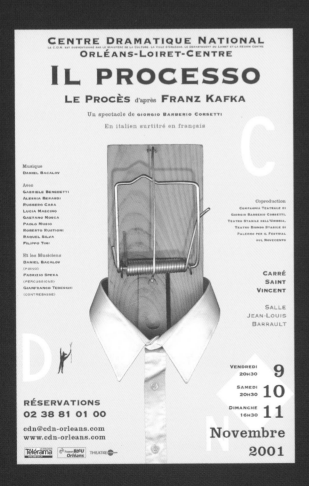

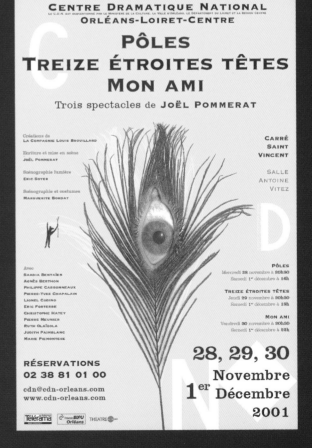

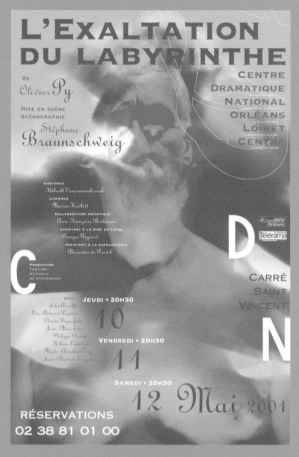

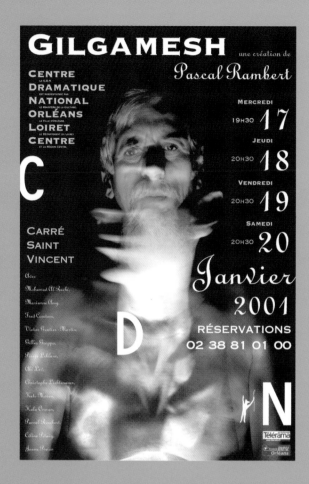

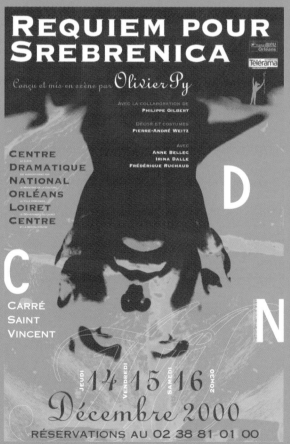

Centre Dramatique d'Orléans

These theater posters demonstrate perfectly how individual pieces can recognizably belong to a series while each standing out memorably in their own right. The designer has constructed a framework of cues, using typography, color, and imagery, to enable passers-by quickly to identify the venue and the season to which the plays belong. The consistently unsettling images, produced by photographic manipulation and montage, further reinforce the collective identity.

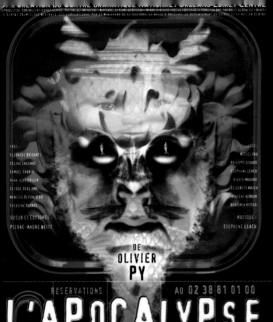

AVEC :
ÉLÉONORE BRIGANTI
CÉLINE CHEENNE
SAMUEL CHURIN
JEAN-JOEL COLLIN
CLAUDE DEGLIAME
MARCIAL DI FONZO BO
SYLVAINE DUPARC

DÉCOR ET COSTUMES :
PIERRE-ANDRÉ WEITZ

AVEC :
MICHEL FAU
PHILIPPE GIRARD
STÉPHANE LEACH
SILVIE MAGAND
ELIZABETH MAZEV
VINCENT DZANON
BENJAMIN RITTER

MUSIQUE :
STÉPHANE LEACH

DE
OLIVIER
PY

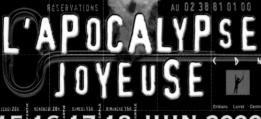

RÉSERVATIONS AU 02 38 81 01 00

L'APOCALYPSE JOYEUSE

〈 D N 〉
Orléans Loiret Centre

JEUDI 20H. VENDREDI 20H. SAMEDI 15H. DIMANCHE 15H.

15 16 17 18 JUIN 2000

CARRÉ SAINT-VINCENT / SALLE JEAN-LOUIS BARRAULT

de Romeo Castellucci Societas Raffaello Sanzio Italie

GENESI
from the museum of sleep

〈 D N 〉
Orléans Loiret Centre

20h en semaine
16h le dimanche

réservations
02 38 81 01 00

décembre 1999
09 au 12

Centre Dramatique National Orléans-Loiret-Centre
Carré Saint-Vincent / 20h / Salle Jean-Louis Barrault

Le C.D.N. est subventionné par le Ministère de la Culture, la ville d'Orléans, le Département du Loiret et la Région Centre

OUVERTURE(S)

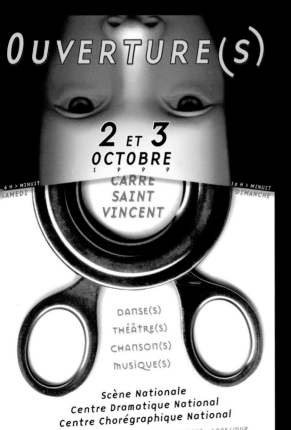

2 ET 3
OCTOBRE
1999

CARRÉ
SAINT
VINCENT

16 H > MINUIT
SAMEDI

16 H > MINUIT
DIMANCHE

DANSE(S)
THÉÂTRE(S)
CHANSON(S)
MUSIQUE(S)

Scène Nationale
Centre Dramatique National
Centre Chorégraphique National

RÉSERVATION : 02 38 42 04 50 - TARIF UNIQUE : 100F/JOUR

Ren 02	Sei 38	Gnez 62	Vous 15	Au 55
Pas	Se	Po	Rt	Pour
Les	〈 D N 〉	6 spectacles	6 lectures	250 francs
	Orléans Loiret Centre	Cré	Ati	Ons

Centre Dramatique National
Orléans-Loiret-Centre. 02.38.62.15.55

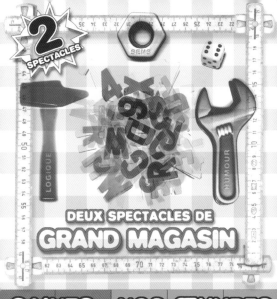

2 SPECTACLES

DEUX SPECTACLES DE GRAND MAGASIN

SAINTS SAINTES	NOS ŒUVRES COMPLETES
JANVIER 2000	JANVIER 2000
11 ➔ 13	14 ➔ 18
COLLÉGIALE SAINT PIERRE-LE-PUELLIER	CARRÉ SAINT-VINCENT SALLE ANTOINE VITEZ

C D N — Orléans Loiret Centre

Centre Dramatique National Orléans-Loiret-Centre
20 h 30 - Réservations au 02.38.81.01.00.

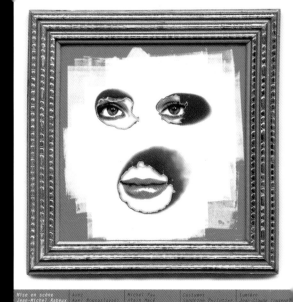

Mise en scène Jean-Michel Rabeux
Avec Axel Bogousslavski, Claude Degliame
Michel Fau, Alain Macé
Costumes Sandrine Pelletier
Lumière Jean-Claude Fonkenel

Meurtres hors champ

de Eugène Durif

C D N — Orléans Loiret Centre

réservations
02 38 81 01 00

octobre	1999	octobre
19	au	24

20h30 en semaine et 16h le dimanche

Centre Dramatique National / Orléans-Loiret-Centre
Carré Saint-Vincent / Salle Antoine Vitez

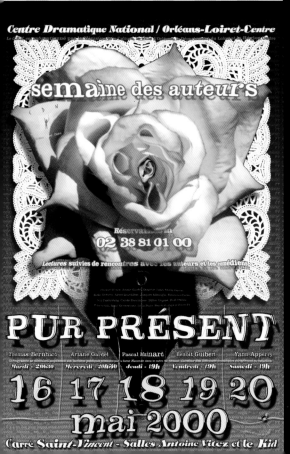

Centre Dramatique National / Orléans-Loiret-Centre

semaine des auteurs

Réservations
02 38 81 01 00

Lectures suivies de rencontres avec les auteurs et les comédiens

PUR PRÉSENT

Thomas Bernhard	Ariane Gardel	Pascal Mainard	Benoît Guibert	Yann Apperry
Mardi - 20h30	Mercredi - 20h30	Jeudi - 19h	Vendredi - 19h	Samedi - 19h
16	17	18	19	20

mai 2000

Carré Saint-Vincent - Salles Antoine Vitez et le Kid

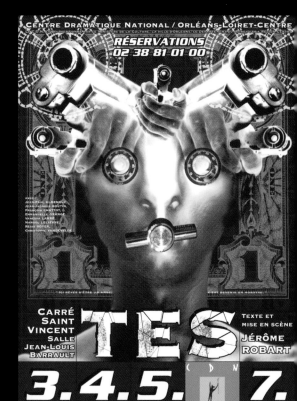

CENTRE DRAMATIQUE NATIONAL / ORLÉANS-LOIRET-CENTRE

RÉSERVATIONS
02 38 81 01 00

Avec
Jean-Paul Albenque
Jean-Jacques Boutin
Françoise Chattot
Emmanuelle Grangé
Vanessa Larré
Manuel Lelièvre
Régo Royer
Christophe Vandevelde

TES

CARRÉ SAINT VINCENT SALLE JEAN-LOUIS BARRAULT

TEXTE ET MISE EN SCÈNE
JÉRÔME ROBART

C D N — Orléans Loiret Centre

3.	4.	5.		7.
20H30 VENDREDI	20H30 SAMEDI	16H00 DIMANCHE		20H30 MARDI

MARS 2000

Kicksology.net

The designers have hit upon the ingenious idea of making a visual pastiche of the label on a typical basketball-shoe box. Not only does this tie in neatly with Kicksology.net's activities, but it also provides an excellent medium for conveying data, such as address and phone number, and can be easily personalized for business cards.

Designers
Anisa Suthayalai,
Ernest Kim (logo)

Art Director
Carlos Segura

Design Company
Segura Inc.

Country of Origin
USA

Description of Artwork
Stationery system
(letterhead, envelope,
business card, mailing
label) for a web-based
review portal for basketball
shoes

Dimensions
Various

The orange–brown background to the logo adds to the basketball theme, evoking the color of basketballs themselves, as well as wood-floored courts.

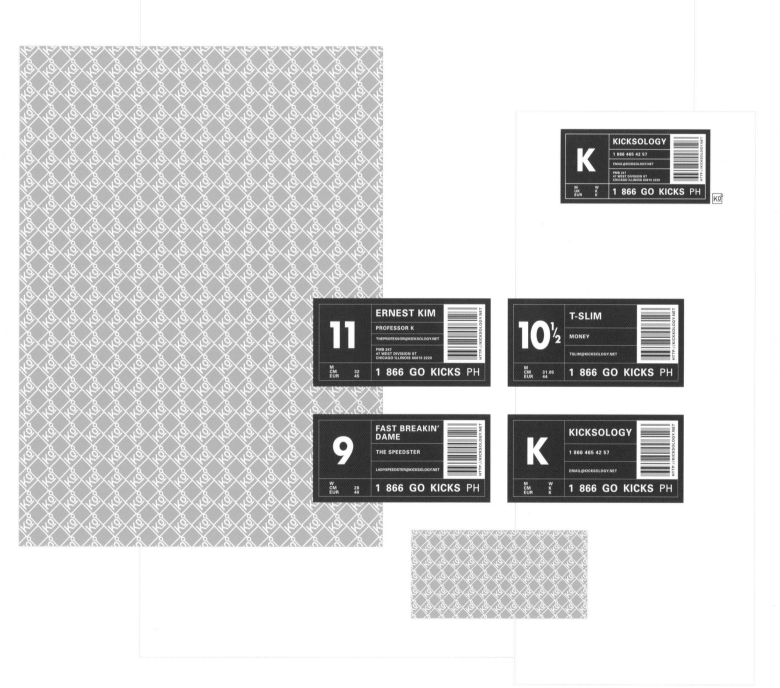

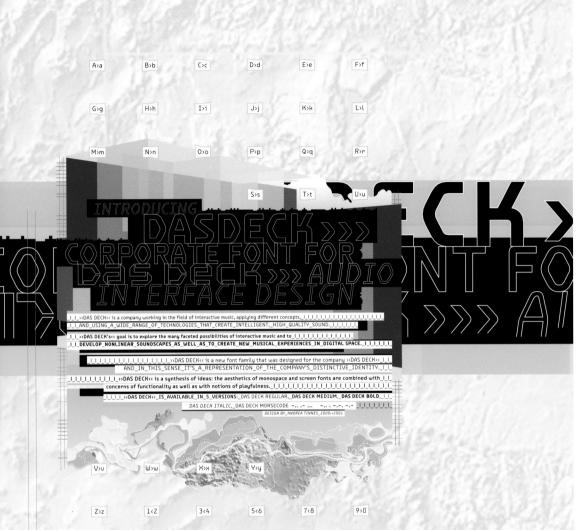

INTRODUCING
DASDECK >>>
CORPORATE FONT FOR
DAS DECK >>> AUDIO
INTERFACE DESIGN

_I_I_>>DAS DECK<< is a company working in the field of interactive music, applying different concepts,_I_I_I_I_I_I_I_I_I_I_I_I_I_I_I
_I_I_AND_USING_A_WIDE_RANGE_OF_TECHNOLOGIES_THAT_CREATE_INTELLIGENT,_HIGH_QUALITY_SOUND._I_I_I_I_I_I_I
_I_I_DEVELOP_NONLINEAR_SOUNDSCAPES_AS_WELL_AS_TO_CREATE_NEW_MUSICAL_EXPERIENCES_IN_DIGITAL_SPACE._I_I_I_I_I_I_I
_I_I_I_I_I_I_I_I_I_I_I_I_I_I_I_I_>>DAS DECK<< is a new font family that was designed for the company >>DAS DECK<<_I_I
_I_I_I_AND_IN_THIS_SENSE_IT'S_A_REPRESENTATION_OF_THE_COMPANY'S_DISTINCTIVE_IDENTITY._I_I
_I_I_I_I_I_I_I_I_I_>>DAS DECK<< is a synthesis of ideas: the aesthetics of monospace and screen fonts are combined with_I_I
_I_I_I_I_concerns of functionality as well as with notions of playfulness._I_I_I_I_I_I_I_I_I_I_I
_I_I_I_I_>>DAS DECK<<_IS_AVAILABLE_IN_5_VERSIONS:_DAS DECK REGULAR,_DAS DECK MEDIUM,_DAS DECK BOLD,_I_I_I
DAS DECK ITALIC,_DAS DECK MORSECODE -.. .- ... -.. .-. .- .-_I_I_I_I_I_I_I
DESIGN BY_ANDREA TINNES_2000<<2001

Designer
Andrea Tinnes

Country of Origin
Germany

Description of Artwork
Poster displaying the font
"DASDECK," designed
on behalf of a company
of the same name which
operates in the field of
interactive music

Dimensions
420 x 595 mm
16¹/₂ x 23¹/₂ in

DASDECK

This typeface acknowledges the forms of telex and
telegram alphabets, with all their implications of urgency
and drama. The moonscapes, maps, and grid coordinates
on the poster create an aura of mystery and exploration
and provide a link between geographical and musical
landscapes. Thus, the poster manages both to promote
the typeface and to reflect Das Deck's business activities.

A>a B>b C>c D>d E>e F>f

G>g H>h I>i J>j K>k L>l

M>m N>n O>o P>p Q>q R>r

S>s T>t U>u

INTRODUCING

DASDECK >>>
CORPORATE FONT FOR
DAS DECK >>> AUDIO
INTERFACE DESIGN

_I_I_»DAS DECK« is a company working in the field of interactive music, applying different concepts,_I_I_I_I_I_I_I_I_I_I_I_I_I_I_I
_I_I_AND_USING_A_WIDE_RANGE_OF_TECHNOLOGIES_THAT_CREATE_INTELLIGENT,_HIGH_QUALITY_SOUND._I_I_I_I_I_I

_I_I_»DAS DECK's« goal is to explore the many faceted possibilities of interactive music and to_I_I_I_I_I_I_I_I_I_I_I
_I_I_DEVELOP_NONLINEAR_SOUNDSCAPES_AS_WELL_AS_TO_CREATE_NEW_MUSICAL_EXPERIENCES_IN_DIGITAL SPACE._I_I_I_I_I_I

_I_I_I_I_I_I_I_I_I_I_I_I_I_I_I_I_»DAS DECK« is a new font family that was designed for the company »DAS DECK«_I_I
AND_IN_THIS_SENSE_IT'S_A_REPRESENTATION_OF_THE_COMPANY'S_DISTINCTIVE_IDENTITY._I_I

_I_I_I_I_I_I_I_I_I_»DAS DECK« is a synthesis of ideas: the aesthetics of monospace and screen fonts are combined with_I_I
concerns of functionality as well as with notions of playfulness._I

_I_I_I_I_»DAS DECK«_IS_AVAILABLE_IN_5_VERSIONS:_DAS DECK REGULAR,_**DAS DECK MEDIUM**,_**DAS DECK BOLD**,_I_I
DAS DECK ITALIC,_DAS DECK MORSECODE −.. .− ... −.. .−.− .− _I_I_I_I_I_I_I

DESIGN BY_ANDREA TINNES_2000<<2001

V>v W>w X>x Y>y

Z>z 1<2 3<4 5<6 7<8 9>0

87

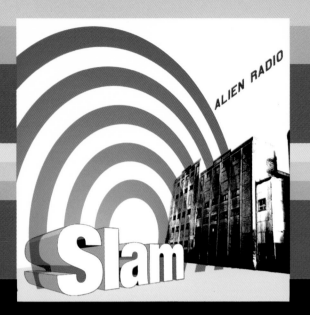

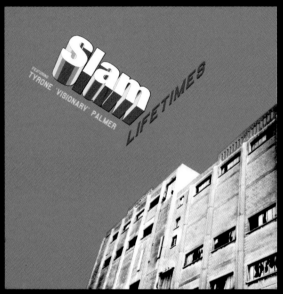

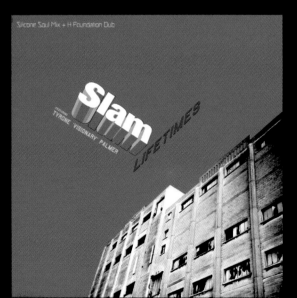

Slam

In keeping with the imposing title of the album (*Alien Radio*) and of the tracks featuring on it, including the single *Lifetimes*, these cover designs adopt a Constructivist ethos—celebrating grand scale and epic engineering. The strength and the simplicity of the central image and the logo design allow these elements to be "remixed," providing a cohesive but adaptable identity.

Designers
Red Design

Photographers
Red Design

Design Company
Red Design

Country of Origin
UK

Description of Artwork
Record sleeve and CD

Dimensions
Record: 305 x 305 mm
12 x 12 in
CD: 140 x 120 mm
$5^{1}/_{2}$ x $4^{3}/_{4}$ in

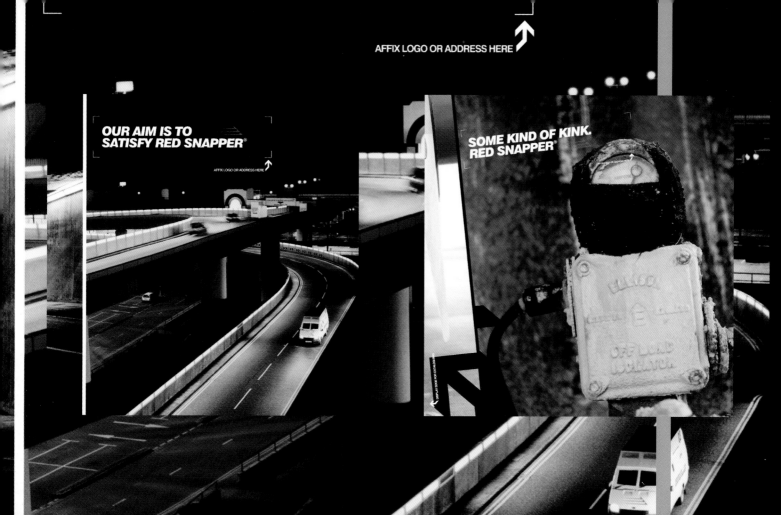

Designers
Red Design

Photographer
Spiros Politis

Design Company
Red Design

Country of Origin
UK

Description of Artwork
Record sleeve and CD

Dimensions
Record: 305 x 305 mm
12 x 12 in
CD: 140 x 120 mm
5^1/$_2$ x 4^3/$_4$ in

Red Snapper

The designers have reinterpreted the title of this dance-music album—*Our Aim is to Satisfy*—as the slogan of a courier company. To reinforce this theme they have borrowed elements from a typical consignment form, such as the three-swoosh logo suggesting speed (of delivery) and the instructions on where to affix address or logo. These motifs reappear on the singles taken from the album, including *Some Kind of Kink*, thus unifying the campaign as a whole.

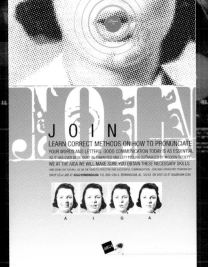

J O I N

LEARN CORRECT METHODS ON HOW TO PRONUNCIATE
YOUR WORDS AND LETTERS. GOOD COMMUNICATION TODAY IS AS ESSENTIAL
AS IT HAS EVER BEEN. DON'T BE THWARTED AND LEFT FEELING OSTRACIZED BY MODERN SOCIETY.
WE AT THE AIGA WE WILL MAKE SURE YOU OBTAIN THESE NECESSARY SKILLS.
AND COME PAY YOU TO JOIN, BE ON THE ROAD TO EFFECTIVE AND SUCCESSFUL COMMUNICATION. JOIN NOW, OPERATORS STANDING BY.
DROP US A LINE AT AIGA/BIRMINGHAM. P.O. BOX 43014. BIRMINGHAM, AL. 35243. OR VISIT US AT AIGABHAM.COM.

A I G A

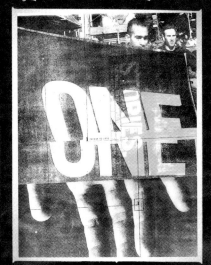

Designers
Nessim Higson, Randy Reed
(Adatech—this page,
background and top inset);
Nessim Higson (all other
pieces)

Illustrator
Nessim Higson (2001 City
Stages—opposite)

Design Company
Lewis Communications
(except Nessim Higson
self-promotional—this
page, bottom inset)

Country of Origin
USA

Description of Artworks
Posters (AIGA and 2001 City
Stages), ad (Adatech), and
self-promotional postcard

Dimensions
Various

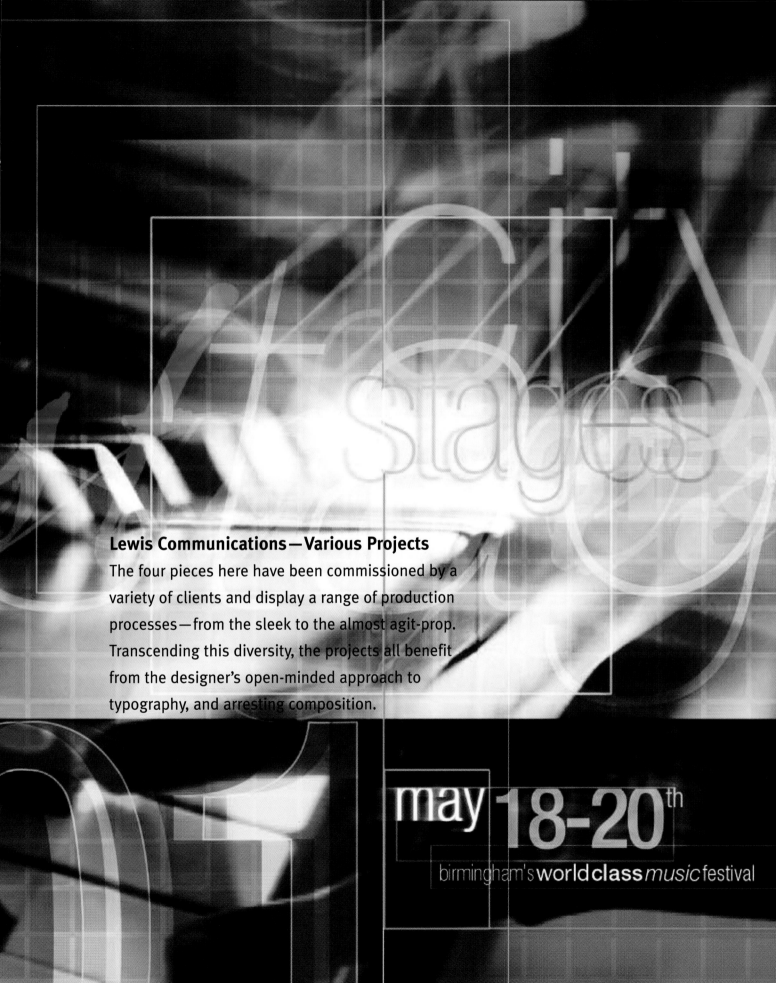

Lewis Communications—Various Projects
The four pieces here have been commissioned by a
variety of clients and display a range of production
processes—from the sleek to the almost agit-prop.
Transcending this diversity, the projects all benefit
from the designer's open-minded approach to
typography, and arresting composition.

may 18-20th
birmingham's **world class** *music* festival

Final Dilation — 4

COVER CLIP BOARD

COVER LETTER

LARGE RUBBER BAND W/ "WHAT'S YOUR STORY?" SILK SCREENED IN WHITE TYPE

H+H

BLACK SILK SCREENED

DISTRICT CRITERIA SHORT-SHEETS: TOTAL 6

DISTRICT CRITERIAS WOULD INCLUDE SUPPORTIVE COPY W/ IMAGES AND DIAGRAMS

CASE STUDIES

CASE STUDIES

CASE STUDIES

CASE STUDIES

CASE STUDIES INC. 4BR LETTERS OFFICE SHEET

CASE STUDIES ILL. PULLOUTS

CASE STUDIES ILL. PULLOUTS

submittal

"image of submittals"

implementations

SCENTS STORYBOARD 1

RETREADS STORYBOARD 1

STORYBOARD 3

STORYBOARD 1

Hollywood & Highland: What's Your Story?

This style guide for architects and interior designers of outlets leased within the Hollywood & Highland entertainment and retail complex is intended not just to instruct but also to inspire. Appropriately for a manual relating to the new home of the Oscars, the book captures the language and many layers of Hollywood: it is bound in a film producer-style clipboard with "submittal" forms and it merges contemporary and historical images from the area.

Designers
Paul Drohan, Don Hollis

Art Director
Don Hollis

Design Company
Hollis Design

Country of Origin
USA

Description of Artwork
A manual laying out the design criteria for outlets leased within an entertainment and retail complex in Los Angeles

Dimensions
305 x 210 mm
12 x 8^1/$_4$ in
(some sheets fold out to a height of 415 mm, 16^1/$_4$ in; others to a width of 585 mm, 23 in)

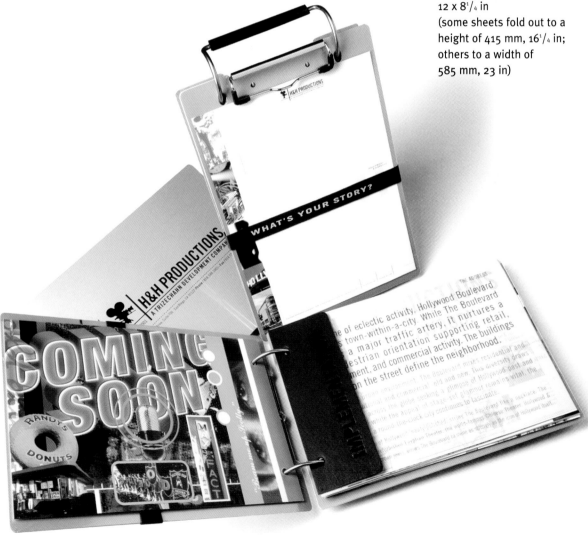

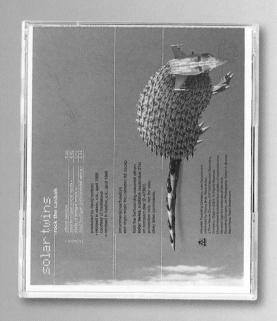

Solar Twins

The eerie, unpopulated land- and seascapes, porcupine-like metal creature, and (alien?) spacecraft breaking into the atmosphere echo the extraterrestrial theme of some of the song titles on the album, such as *Out There* and *Astral Hymn*. The tiny image of an oil well (left, center) may hint at a concern for the future of our own planet.

Designer
Stefan G. Bucher

Illustrator
Stefan G. Bucher

Photographers
Stefan G. Bucher, Geoff Moore, Ann Short, StGB, NASA/Caltech/JPL

Design Company
344 Design, LLC for Maverick Recording Co.

Country of Origin
USA

Description of Artwork
CD package for British drum'n'bass duo Solar Twins

Dimensions
140 mm x 125 mm
5'/₂ x 5 in

Digital manipulation has been used to create two cover designs from the one image—sea has become desert, and fertile shoreline arid mountains.

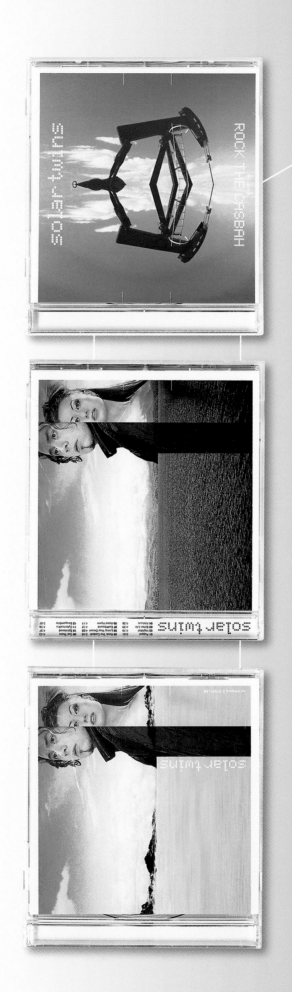

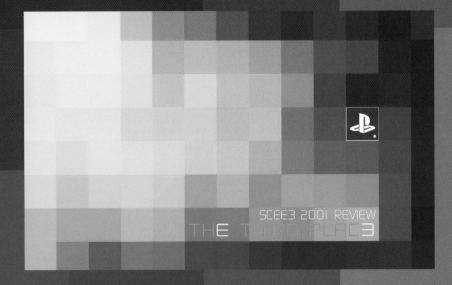

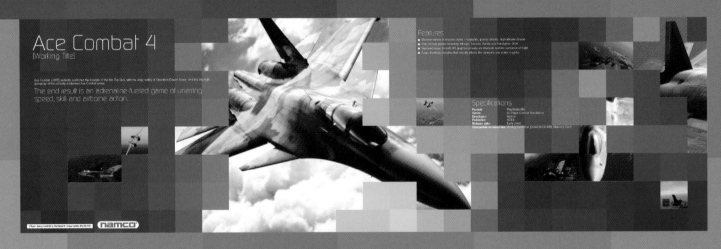

Ace Combat 4
[Working Title]

Ace Combat 4 (WT) perfectly combines the bravado of the film Top Gun, with the edgy reality of Operation Desert Storm, and the dog-fight gameplay of the critically-acclaimed Ace Combat series.

The end result is an adrenaline-fuelled game of unerring speed, skill and airborne action.

Features
- Massive variety of mission styles — dogfights, ground attacks, high-altitude chases
- Over 20 real planes including: Mirage, Tornado, Rafale and Eurofighter 2000
- Improved super smooth 3D graphics provide an intensely realistic sensation of flight
- Deep, involving storyline that clearly affects the missions you make in-game

Specifications
Format: PlayStation®2
Genre: 3D Flight Combat Simulation
Developer: Namco
Publisher: SCEE
Release date: Early 2001
Compatible accessories: Analog Controller (DUALSHOCK®), Memory Card

namco

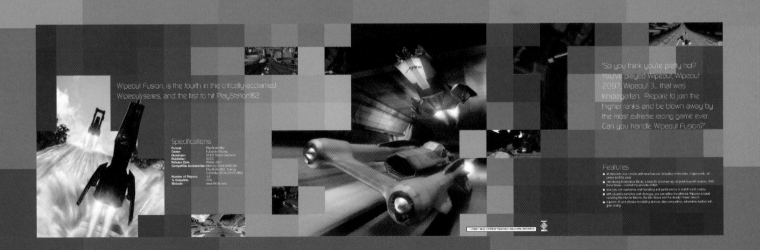

Wipeout Fusion, is the fourth in the critically-acclaimed Wipeout series, and the first to hit PlayStation®2

Specifications
Format: PlayStation®2
Genre: Futuristic Racing
Developer: SCEE Studio Liverpool
Publisher: SCEE
Release Date: Winter 2001
Compatible Accessories: Memory Card (8MB) for PlayStation®2, Analog Controller (DUALSHOCK®2)
Number of Players: 1-2
% Complete: 75%
Website: www.scee.com

"So you think you're pretty hot? You've played Wipeout, Wipeout 2097, Wipeout 3... that was kindergarten. Prepare to join the higher ranks and be blown away by the most extreme racing game ever. Can you handle Wipeout Fusion?"

Features
- All tracks will now include new features including: corkscrews, trigger pads, air jumps and flip pads
- Introducing Endurance Mode, a new 3D shoot-em-up on point-to-point courses, AND Zone Mode — overkill by any other title!
- Now you can experience craft handling and performance to match each chassis
- With situation-sensitive craft damage, you can now utilise the ultimate Wipeout arsenal including the Hunter Missile, the Bio Seizer and the deadly Power Shock
- Superior AI and physics including dynamic, ultra competitive, infuriating hud and your daring

SCEE3 2001 Review

To reflect the nature of the products that it promotes, the layout of this printed brochure brings to mind web-page and game design, with text and images positioned in blocks, and icons, logos, and boxed information in small print at the bottom of the page. The digital theme is continued in the background grid of small colored squares that resembles a magnified view of a pixellated image. The grid also refers to split-screen visual presentation, a device used in game design.

Designers
Fluid Design

Design Company
Fluid Design

Country of Origin
UK

Description of Artwork
Brochure to accompany Sony's presence at the Electronic Entertainment Expo (E3) in Los Angeles

Dimensions
297 x 180 mm
$11^3/_4$ x 7 in

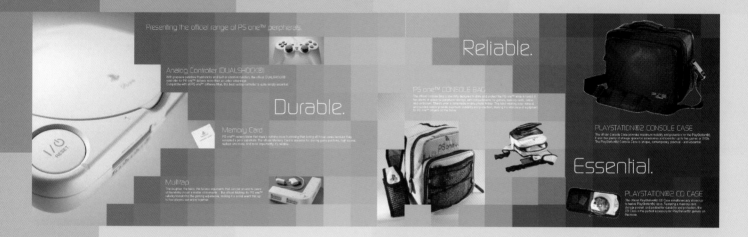

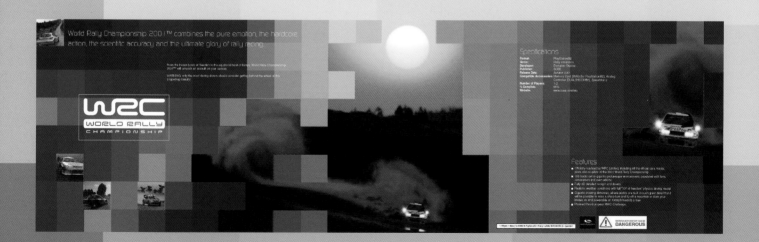

PS2

In this brochure to promote PlayStation 2 games, the designers demonstrate the high quality of the game graphics by presenting stills from games as if they were real-life street scenes. The magazine-style layout adds to the feeling of authenticity. Background blacks and grays and the vertical stripes running down the edge of the page reflect the packaging of the PlayStation and the appearance of the console itself.

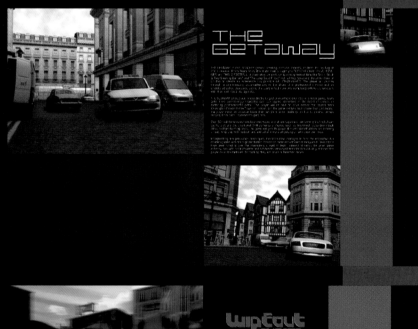

Designers
Fluid Design

Design Company
Fluid Design

Country of Origin
UK

Description of Artwork
Brochure to accompany Sony's presence at the Electronic Entertainment Expo (E3) in Los Angeles

Dimensions
245 x 245 mm
$9^3/_4$ x $9^3/_4$ in

foodnotes'
15a purvis street
singapore 188594.
tel: 220.1002.
fax: 334.7262.

tham suet yin.
director
9638.6201

foodnotes˙
15a purvis street
singapore 188594.
tel: 220.1002.
fax: 334.7262.

angelena chan.
director
9753.9339

foodnotes˙
15a purvis street
singapore 188594.
tel: 220.1002.
fax: 334.7262.

Designer
Hanson Ho

Design Company
H55

Country of Origin
Singapore

Description of Artwork
Stationery, including
letterhead and business
cards, for Foodnotes—
a food consultancy
specializing in creating
or experimenting with
new recipes and flavors

Dimensions
Various

Foodnotes

The logo for this recipe-development consultancy has
been conceived to reflect one of the core activities of
Foodnotes: experimenting with the blending of
ingredients or flavors (represented by each of the bars)
in subtly different proportions. The abstract nature of
the design also refers to other food-related graphic
symbolism: for example, a chart presenting the findings
of a market-research taste test on a new recipe, a scale
giving heating recommendations on food packaging, or
a cooker-fascia design.

The designer has found room for
a subtle typographic pun on the
letterhead. By putting the company
contact details at the bottom of the
sheet with an asterisk after the
company name, he plays on the
similarity of the word "foodnotes"
to "footnotes."

arbeiten Menschen, die ihr Handwerk beherrschen und sehr ernsthaft mit Materialien und Formen spielen. Menschen, deren Phantasien ganz greifbar Gestalt annehmen: als Tisch, Stuhl, Kleid, Lichtskulptur, Schmuck-Stück. Ihre Werkstätten und Ateliers liegen nicht an den bekannten Einkaufsmeilen. Sie sind nicht immer leicht zu finden, machen keine Werbung und oft von außen nicht viel her. SEIN & SIGN ist ein Schaufenster für diese ungewöhnlichen, oft einzigartigen Objekte und ein Wegweiser für Individualisten - hin zu den Menschen und ihrer unverwechselbaren Phantasie, die sich in großen und kleinen Gebrauchs-Kunstwerken zu erkennen geben. SEIN & SIGN erzählt Geschichten von Menschen und ihren Dingen, stellt Künstler und Handwerker vor, die diese Dinge machen.

Der herausnehmbare Mittelteil „EURO-CITY" ist ein Wegweiser zu den interessantesten Werkstätten und Galerien jeweils einer europäischen Stadt: von London bis Berlin, Amsterdam, Venedig, München, Paris, Mailand, Köln, Barcelona; nicht zu vergessen Pforzheim, Halle, Zürich, Basel, Wien und Prag.

Noch freilich ist's nur eine Probenummer, die vor Ihnen liegt Noch gibt es keine redaktionellen Mitarbeiter und keinen kommerziellen Vertrieb. Wir zeigen, wie diese Zeitschrift aussehen kann. Auf Ihre Anregungen sind wir gespannt.

Ihre *Cornelie Ueding*

Keramik Jennifer

Wohnzimmer, Diele oder Ausstellungsraum werden so plötzlich zur Mär-chenwiese, zur Wüste, zur flachen Bucht, in der Flamingos gründeln, zum Urwald, in dem die Bäume, wenn schon nicht in den Himmel, so doch durch den Tisch wachsen. Ein spiegelbildliches Zwillingsstuhlpaar versetzt den Betrachter umstandslos in einen Palmenhain. Und wenn auch von Stühlen mit Palmwedellehne kein Schatten zu erwarten ist, so laden sie doch zur Rast ein, zum innehalten in der Einöde der geschniegelten Normteile. Wir erleiden die gebaute Wüstenei, vor der ein ganzes Volk

> *Reiseandenken, Trophäen aller Art. Kein Zweifel, zu dem, der darin wohnt, sprechen alle diese Dinge, die Photos, Keramiken, Salzteigkränze und Trockenblumensträuße, die Artefakte.*

die Schutzzone der Privaträume flieht, deren Ver-wendung von Planern vor-gezeichnet und vor-geschrieben ist; und deren Möblierung mit millimetergenau eingepaßten Standardteilen nichts im Wege steht. Und weil jeder Mensch den berechtigten Wunsch hat, einem Raum seine Prägung, also eine persönliche Note zu geben, füllen sich die Regale und Wände mit Erinnerungsstücken, Reiseandenken, Trophäen aller Art. Kein Zweifel, zu dem, der darin wohnt, sprechen alle diese Dinge, die Photos, Keramiken, Salzteigkränze und Trockenblumensträuße, die Bilder und Artefakte. Sie erzählen und bestätigen sein eigenes, gelebtes Leben, regen nostal-gische Träume an, vermitteln ein Gefühl des Wohlbehagens und der Geborgenheit – wo andere möglicherweise nur ein Sammelsurium von Kinkerlitzchen sehen oder sich von der Fülle angehäufter, lebloser Gegenstände bedrängt fühlen und zum Ausmis-ten raten. Dann gibt es auch noch die Wohnräume, die man kaum als solche bezeichnen kann. Repräsentative schnieke Leere herrscht hier, gelebt wird in der Küche oder im Partykeller. Mit anderen Worten: Kein persönlicher Gegenstand stört mehr.

Adresse in Amsterdam:
Jennifer Lee
Hammerstraat 345
6817 NC Amsterdam
telefoon +31 (29)45 679 2
fax +31 (29) 45 679 217
U-Bahn Straaterpad, U7

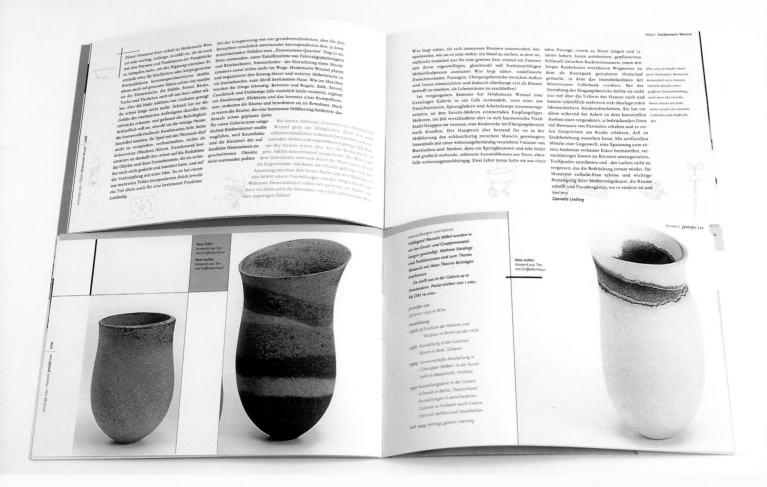

sein & sign

sein & sign magazine sets out to describe, analyze, and present the work of artists and craftsmen across a range of disciplines. It also features a useful city guide supplement, that can be viewed in A4 and folded down for ease of transport while exploring a city and its artists.

Designer
Esther Mildenberger

Illustrators
Various

Photographers
Various

Design Company
envision+

Country of Origin
Germany

Description of Artwork
Magazine with city guide supplement

Dimensions
Magazine: 230 x 297 mm
9 x 11³/₄ in
City guide: 210 x 148 mm
8¹/₄ x 5³/₄ in

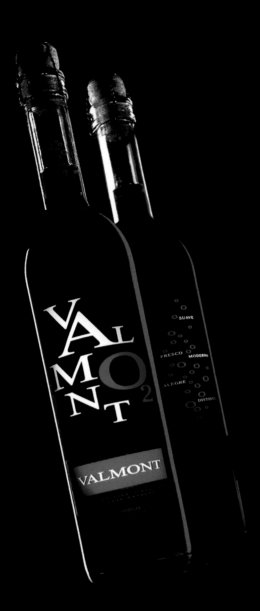

In another break with convention, the graphics are printed directly onto the bottle itself, rather than onto a label.

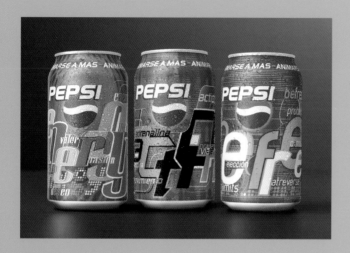

Designer
Diego Giaccone

Design Company
Interbrand Avalos & Bourse

Country of Origin
Argentina

(opposite page)
Description of Artwork
Packaging for a brand of
sparkling red wine

Dimensions
n/a

(this page)
Digital Artwork
Sergio Galeano,
Mariano Grassi

Description of Artwork
Three designs for Pepsi
cans

Dimensions
n/a

Valmont O₂/Pepsi—Animarse a Más

The packaging for the sparkling red wine Valmont O₂
(opposite page) deliberately reflects the genre-bending
nature of the product. At first sight the shape of the
bottle suggests a conventional red wine, but
expectations are confounded by the champagne-style
cork and coiled-wire cover.

The Pepsi-can designs (this page) demonstrate how
a strong global brand identity can withstand even quite
radical regional variations. The positive message
conveyed by the keywords on the cans is supported by
an effervescent typographic approach, with clever use of
color to pick out words within words—for example, "sí"
(yes) within "pasión" (passion).

EDS-Comdex Keynote Presentation

The designers of this short video to promote a data delivery company took a leap of imagination—portraying the streets and buildings of downtown Las Vegas as data would see them and allowing the viewer to travel with the data. This is a much more inspired way of representing a company in this business sector than the commonplace image of data speeding along a cable. Linc have used techniques such as stop-motion footage and digital color manipulation to achieve an appropriately otherworldly effect.

Designers
Ed Apodaca, Lisa Berghout,
Lesa Herrera

Art Director
Lisa Berghout

Video Photography
Mortarotti Ramirez
Productions for OPTS
Events

Design Company
l.inc design

Country of Origin
USA

Description of Artwork
Video sequence featuring
stop-motion footage to
represent data traveling
across a citywide network.
Commissioned as part of
a presentation by EDS-
Comdex, a data delivery
company.

Dimensions
35 mm film converted to
digital Beta: 405 x 230 mm,
16 x 9 in

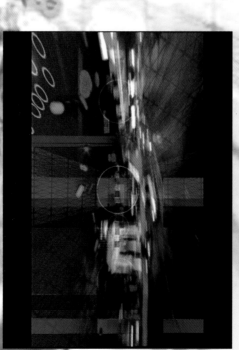

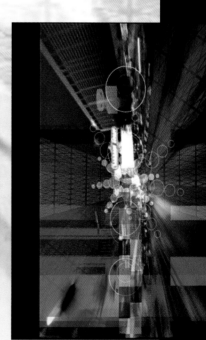

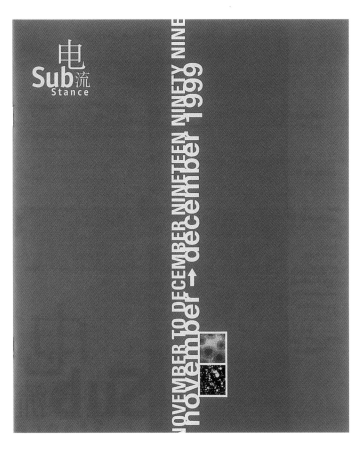

Designer
Hanson Ho

Design Company
H55

Country of Origin
Singapore

Description of Artwork
Magazine produced by
The Substation, a center
for the arts

Dimensions
210 x 245 mm
8¹/₄ x 9³/₄ in

Substance: November–December 1999

Although always present on the cover of any periodical,
the date of the issue is normally tucked away in a corner
in minuscule type. Here, to mark the end of the 1900s,
the natural order of magazine cover design is turned on
its head: the date is the main feature, relegating the
issue's contents to two tiny squared-up images toward
the bottom.

The interior of this particular issue
(opposite page) also departs from
its normal design, with grids and
typography varying from spread to
spread. Like the date on the cover,
the normally unobtrusive folios
sometimes occupy an unusually
prominent position.

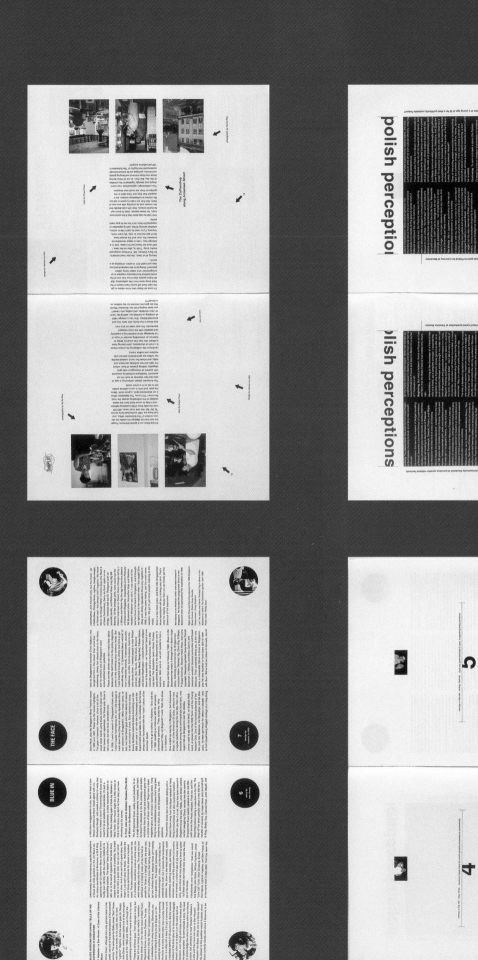

stanton warriors_
the stanton session_

the album

Stanton Warriors

The wild streaks and spatters of paint used on these designs are reminiscent of the Abstract Expressionist movement in American art in the 1950s and as such suggest an explosion of creative energy and the breaking down of barriers. The designers have sampled parts of a larger artwork for individual elements of the packaging, thereby creating a loose but strong visual identity.

stanton warriors_
the stanton session_

Designer
Scott Minshall

Illustrators
Tom Hingston, She-One

Photographer
Scott MInshall

Design Company
Mint

Country of Origin
UK

Description of Artwork
12" promo record, logo
development

Dimensions
315 x 315 mm
$12^1/_2$ x $12^1/_2$ in

The designs below show the stages
involved in the development of a logo
for the Stanton Warriors. The logo
itself is reminiscent of sportswear
logos and graffiti artists' tags.

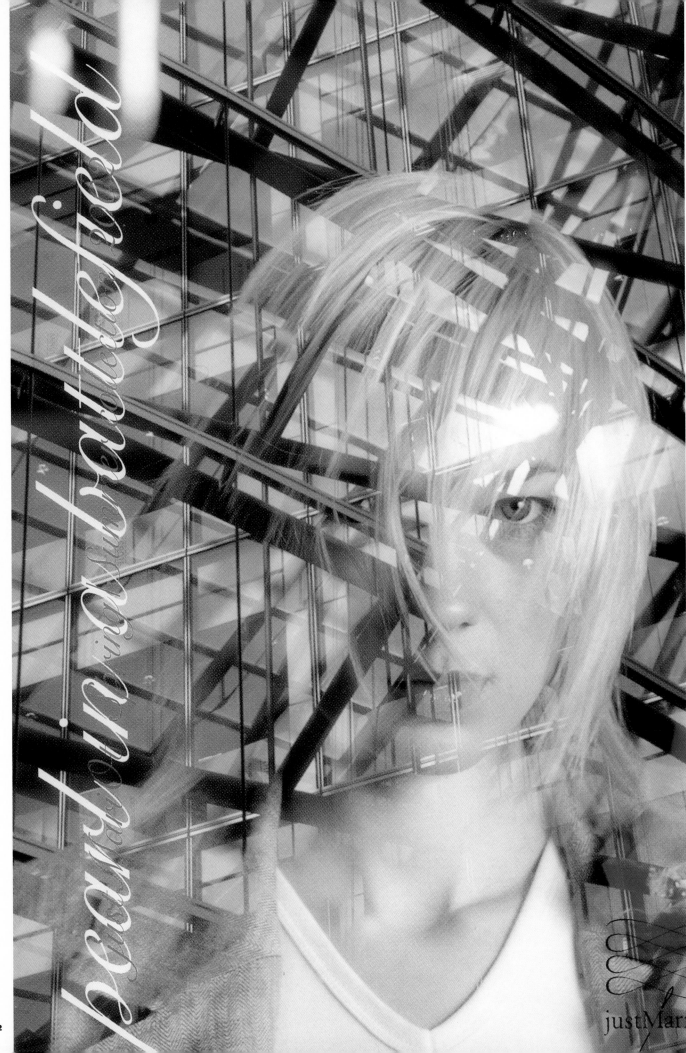

aboutyourtroubledworld

justMari

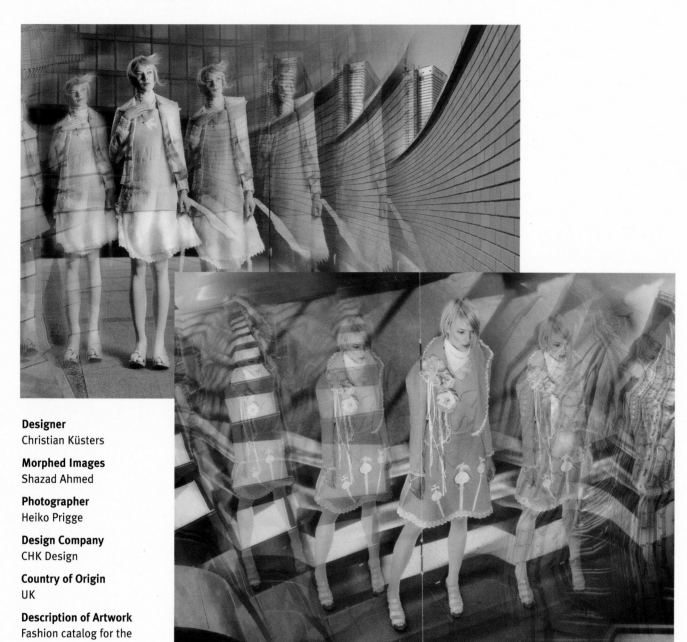

Designer
Christian Küsters

Morphed Images
Shazad Ahmed

Photographer
Heiko Prigge

Design Company
CHK Design

Country of Origin
UK

Description of Artwork
Fashion catalog for the
Just Mariot label

Dimensions
148 x 210 mm
5³/₄ x 8¹/₄ in

The juxtaposition between war and
peace is present in the clothes
themselves—note the dove and the
sword handles on the front of the
dress (above).

Pearl in a Battlefield

The design of this fashion catalog reflects the contrast
between war and peace, hard and soft, suggested by
the title of the collection. With the implication that the
modern business world is a battlefield, stark, futuristic
office blocks provide an arrestingly incongruous
backdrop to the soft, romantic clothing.

Information is Control, Disguised as Chaos

This ad illustrates a complex and abstract concept: that information technology, although it seems unfathomable, can be harnessed and used by anyone. In this instance the designer has chosen typography as the main vehicle for the message, presenting the central slogan in an array of wildly contrasting typefaces and sizes, and showing it scrambled and fragmented in the manner of bits of data.

Designer
Lisa Berghout

Art Director
Sean Farrell at
Goodby Silverstein
& Partners

Illustrator
Lisa Berghout

Design Company
l.inc design

Country of Origin
USA

Description of Artwork
Pitch for a magazine
ad campaign for a
telecommunications
company

Dimensions
432 x 279 mm
17 x 11 in

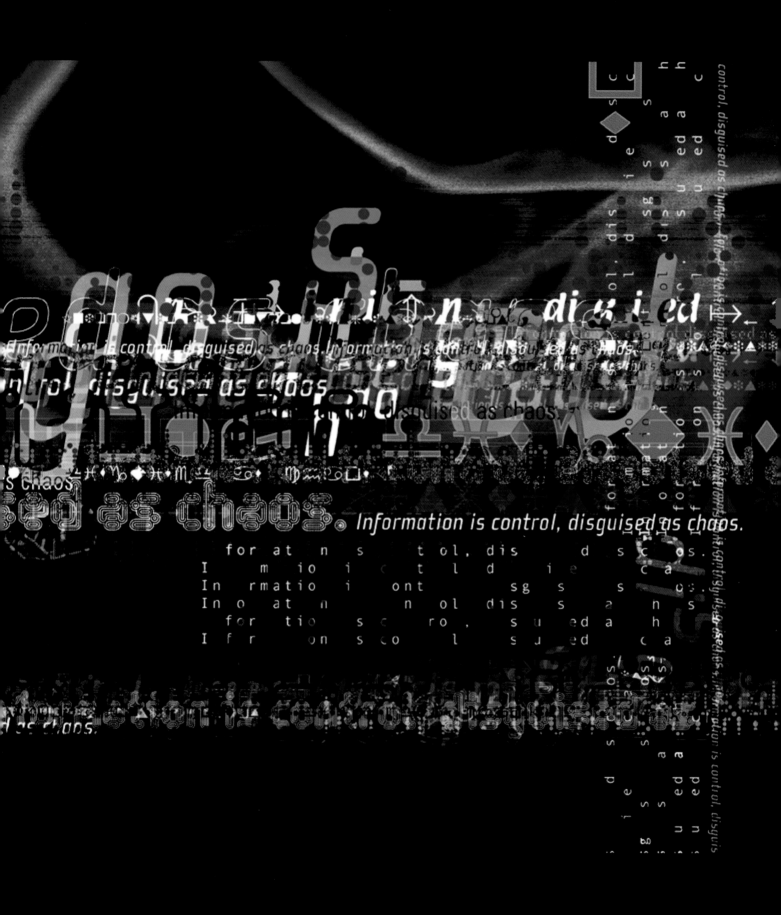

Information is control, disguised as chaos. Information is control, disguised as chaos.

Information is control, disguised as chaos.

The Spirit of Malaysian Architecture 2000

The designers have systematically treated this book as if it were a building. It has a standard grid onto which text and images are laid like building blocks. Like the interiors of a company headquarters, the pages are decked out in PAM's corporate colors. Even the title typeface has been designed to resemble building blocks.

Designers
Dzurina Dzulkhaini,
Ifzan Ibrahim

Art Directors
Dzurina Dzulkhaini,
Yati Dzulkhaini,
Ifzan Ibrahim

Design Company
theclickproject//
graphicdesignbureau

Country of Origin
Malaysia

Description of Artwork
Book showcasing the
entrants to the annual
architecture competition
run by PAM—the Malaysian
Institute of Architects

Dimensions
170 x 240 mm
6³/₄ x 9¹/₂ in

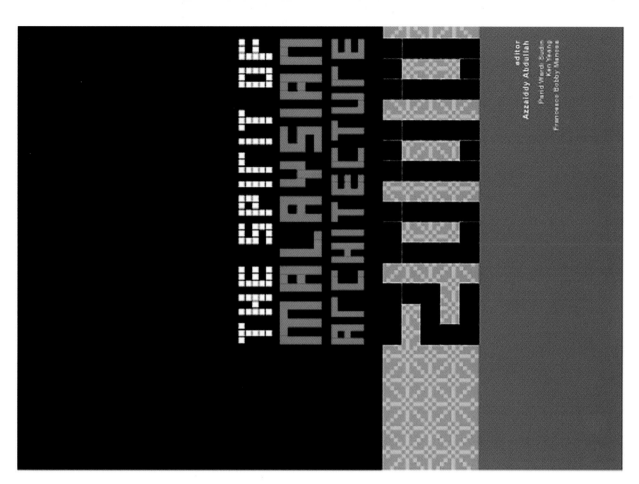

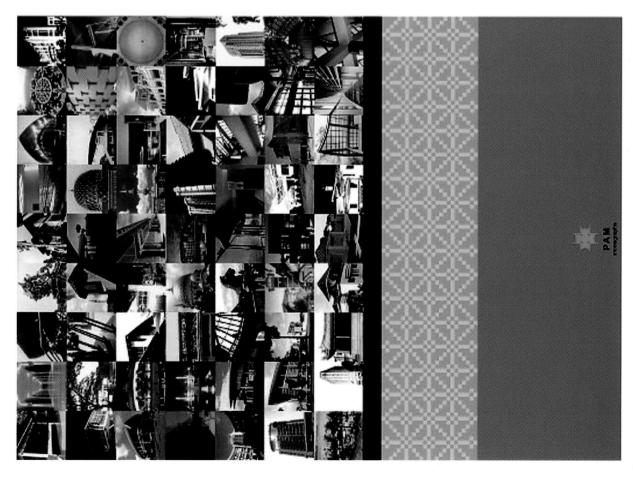

Dental Advice T-shirt

The designers have brought the fundamentals of dental hygiene into the information age. The rows of icons on this T-shirt, urging children to take such steps as brushing their teeth, visiting the dentist, and drinking milk are reminiscent of the home page of a website—a cunning way of making tiresome tasks seem relevant and appealing.

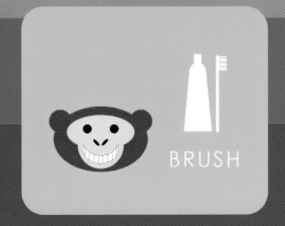

Designer
Ifzan Ibrahim

Art Director
Yati Dzulkhaini

Illustrator
Ifzan Ibrahim

Design Company
theclickproject//
graphicdesignbureau

Country of Origin
Malaysia

Description of Artwork
T-shirt design featuring six artworks, each giving advice for children on how to look after their teeth. The T-shirt was sold at FDI, an international dental exhibition.

Dimensions
Individual artworks:
190 x 120 mm
7^1/$_2$ x 4^3/$_4$ in

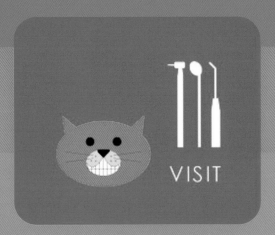

DRINK

LOVE

EAT

FLOSS

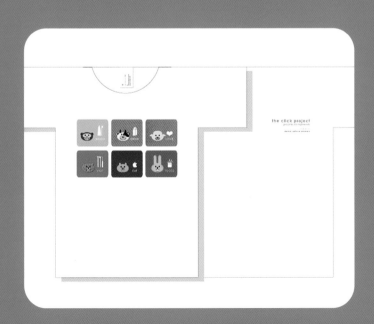

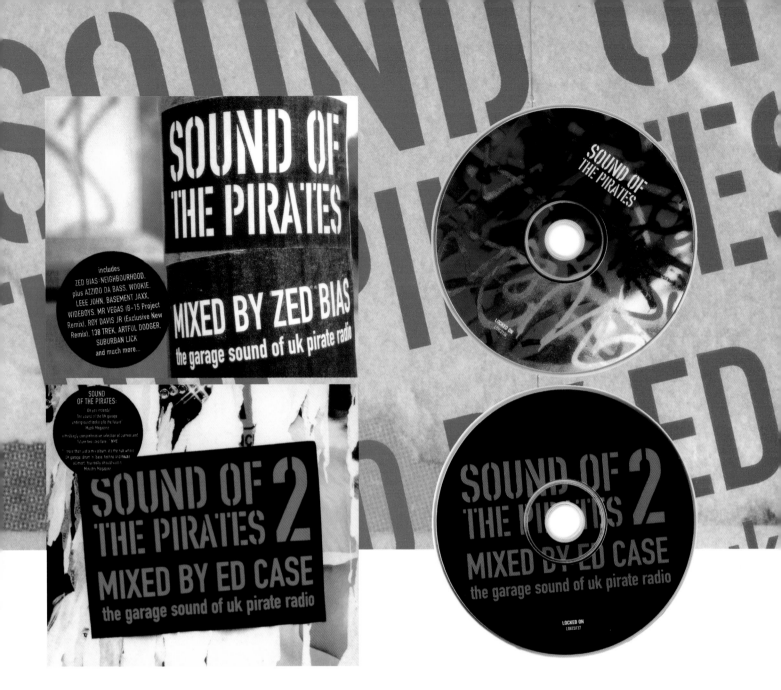

Sound of the Pirates 2

In keeping with the musical genre featured on this
compilation album, the designers have drawn upon the
visual vocabulary of the street, sampling graffiti and
flyposters. The stencil typeface mimics the template used
for spraypainting text directly onto a wall at speed,
reinforcing the notion of unauthorized activity suggested
by the title of the album.

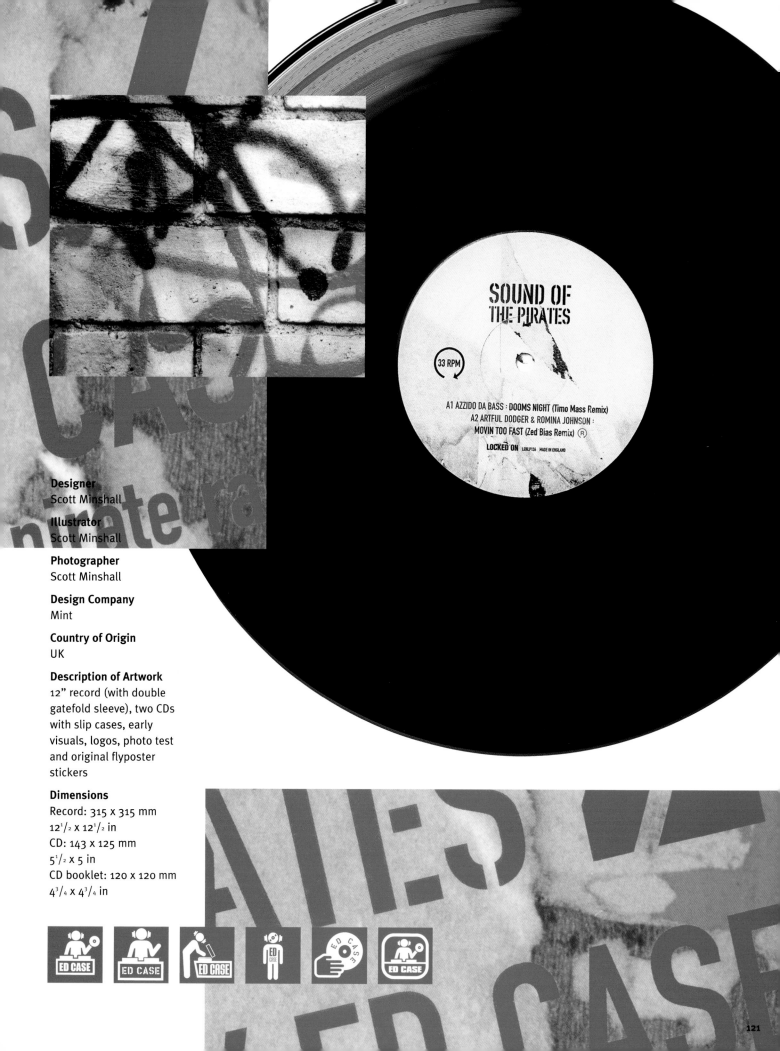

Designer
Scott Minshall

Illustrator
Scott Minshall

Photographer
Scott Minshall

Design Company
Mint

Country of Origin
UK

Description of Artwork
12" record (with double
gatefold sleeve), two CDs
with slip cases, early
visuals, logos, photo test
and original flyposter
stickers

Dimensions
Record: 315 x 315 mm
12$^1/_2$ x 12$^1/_2$ in
CD: 143 x 125 mm
5$^1/_2$ x 5 in
CD booklet: 120 x 120 mm
4$^3/_4$ x 4$^3/_4$ in

Junkmail Bus

A bus or tram makes for a challenging "canvas" because the area to be covered is broken up by windows and wheel arches. By using small, squared-up images of products from a supermarket leaflet, the designer has overcome this problem, at the same time providing a witty interpretation of the theme of going shopping by public transport.

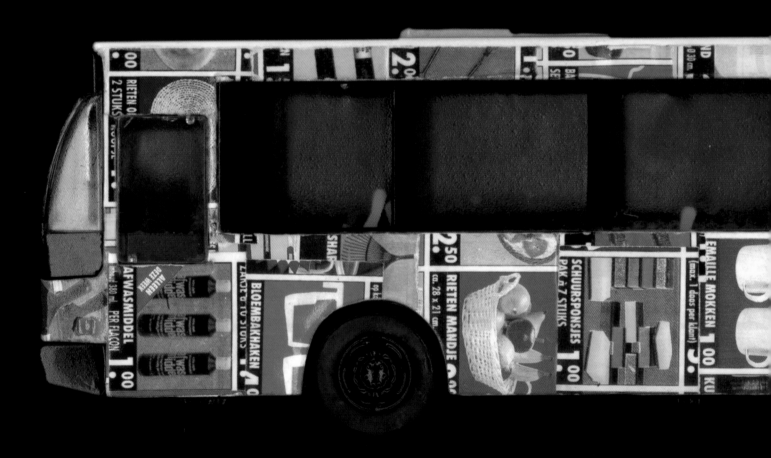

Designer
Martijn Oostra

Country of Origin
The Netherlands

Description of Artwork
Design for a bus or tram

Dimensions
n/a

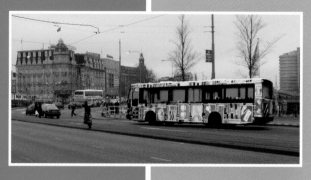

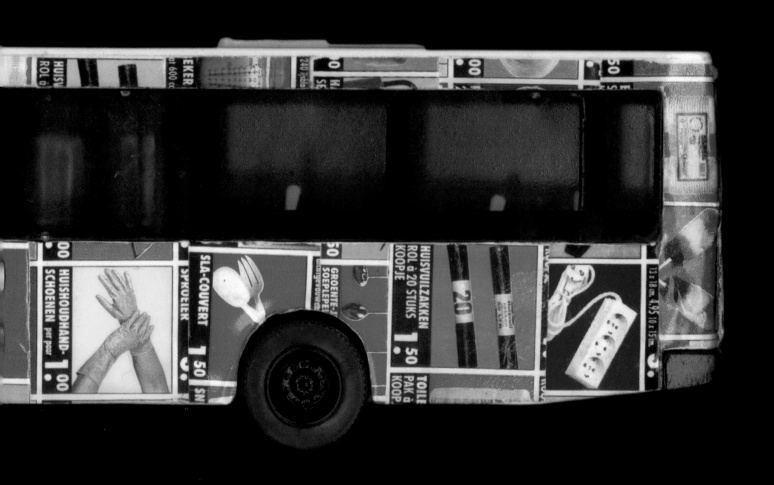

The Artist's World/Utopia Now!

This single volume is in fact two exhibition catalogs bound back to back—an economical and elegant solution that enables high production values to be maintained in the face of a small and finite production budget. To switch between the two catalogs, the reader has to turn the book upside down, and what one would expect to be the back cover of *Utopia Now!* is actually the front cover of *The Artist's World.*

As well as the orientation of the pages, the designer uses typography and layout to distinguish between the two catalogs.

THE ARTIST'S WORLD

Paul McCarthy
Dave Muller
Jim Shaw
Guy Richards Smit
Bob & Roberta Smith
Michael Smith and Joshua White
Annika Ström

Designer
Bob Aufuldish

Publication Manager
Nancy Crowley

Design Company
Aufuldish & Warinner

Country of Origin
USA

Description of Artwork
Two exhibition catalogs bound back to back— produced for the Californian College of Arts and Crafts Institute for Exhibitions and Public Programs

Dimensions
133 x 185 mm
5¼ x 7¼ in

UTOPIA NOW!

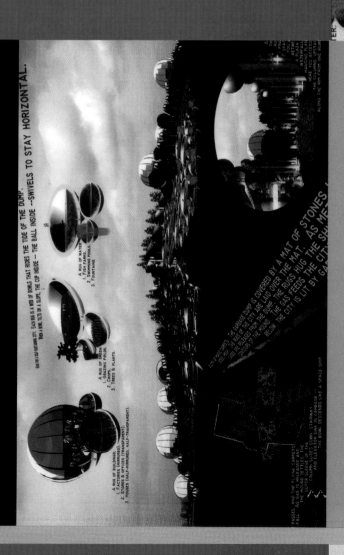

Vito Acconci/Acconci Studio
Shigeru Ban
Santiago Cirugeda
Crimson
Amy Franceschini
Chad McCail
Nils Norman
Raketa
Michael Rakowitz
Superflex
Torolab

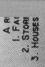

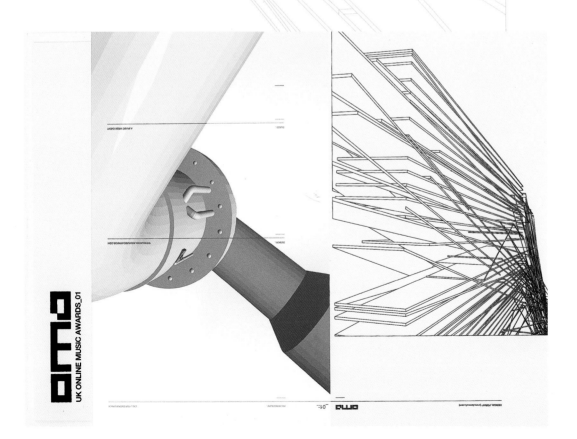

UK Online Music Awards_01 (OMA_01)

Old-industry terms such as "construction," "architecture," and "engineering" have been commandeered by the new technology of website design. The designers of this branding system for an online music awards acknowledge the origins of this terminology by using images of pipework to symbolize the infrastructure and construction of a website. The interplay between the pipework, the dynamic abstract line work, and the distinctive typeface creates a memorable and versatile identity system.

(this and following spread)
Designers
Paula Benson,
Tom Crabtree,
Chris Hilton, Paul West

Art Directors
Paula Benson, Paul West

Illustrators
Tom Crabtree, Chris Hilton

Design Company
Form

Country of Origin
UK

Description of Artwork
Branding for an online music awards ceremony, including logo, identity, promotional items, and literature

Dimensions
Various

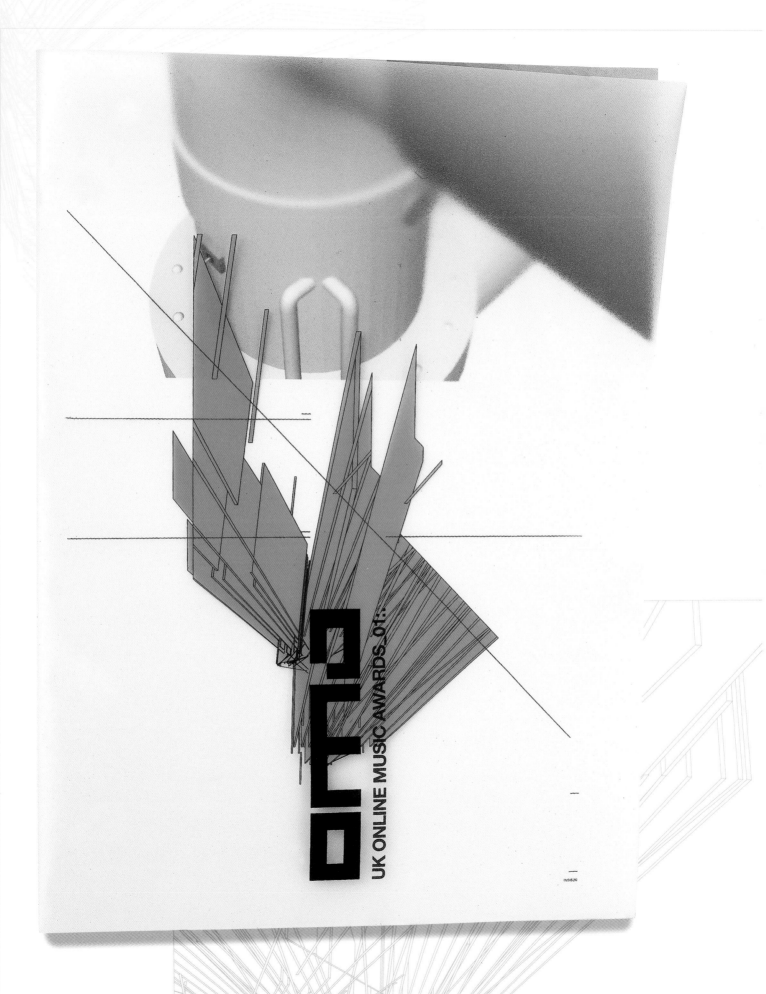

omo

UK ONLINE MUSIC AWARDS_01:

oma

UK ONLINE MUSIC AWARDS_01:.

WWW. ONLINEMUSICAWARDS.COM/

DESIGN.

BUILD.

A MUSIC WEEK EVENT.

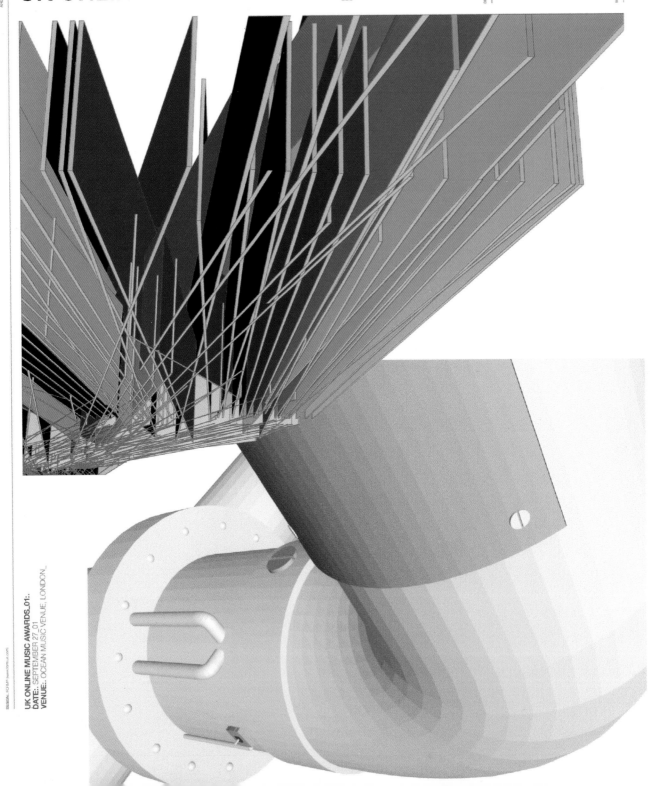

DESIGN.: FC3147. www.oma.uk.com/

UK ONLINE MUSIC AWARDS_01:.
DATE.: SEPTEMBER 27_01
VENUE.: OCEAN MUSIC VENUE, LONDON_

wiseconnect™

TOOLS

3.

2.

1.

HELPING YOU WORK SMARTER.

- - - - - - - - - - - - - - - - - -
YOUR WORKBOOK

Designers
Tom Sieu, John Givens

Illustrators
Tom Sieu, John Givens

Design Company
Tom & John: A Design
Collaborative

Country of Origin
USA

Description of Artwork
Brochure for Wiseconnect,
a company that produces
software for the design and
construction of retail stores

Dimensions
228 x 304 mm
9 x 12 in

Wiseconnect Tools Workbook

By featuring a variety of simple shapes in strong, flat
colors, the design of this brochure underpins the
desired message: that although the technology
involved in this store-design package is complex, the
software is nonetheless easy to use. The image of
an easily navigable maze reinforces the theme of
simplicity—at once reflecting the consumer's passage
through a store and the retailer's journey toward the
optimum store layout.

SHARED
DOCUMENTS

MARKET
PLACE

STORE
PLANNER

WORK
SPACE

INSTALLATION
CALENDAR

EMAIL

NEWS

MY
CONNECT

INVENTORY
AUCTION

SIMPLIFYING RETAIL:

1-2-3

Retail is a fast-paced, cutthroat
industry with low margins and
shifting consumer demand.

MAKING A CONNECTION:

To be a market leader, Retailers need an enticing store presence, well-merchandised product, and a brand that drives sales. Store development and management plays an integral role in a Retailer's business, acting as the gatekeeper for success in the consumer marketplace.

The market requires Retailers to plan and respond in real-time. However, Retailers need the proper tools for quick deployment of new stores, as well as efficient management of existing real estate.

WiseConnect is the digital destination for professionals in the retail fixture and display industry with tools designed to help you work smarter – not harder... We provide a synergetic solution unlike anything available to retail professionals today.

LEARN MORE ➡

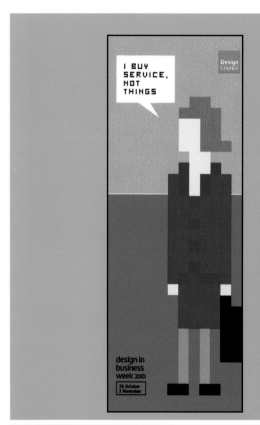
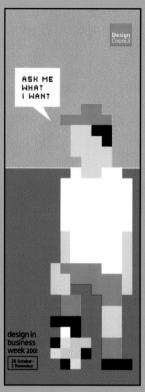
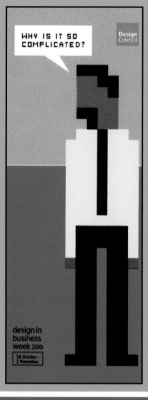
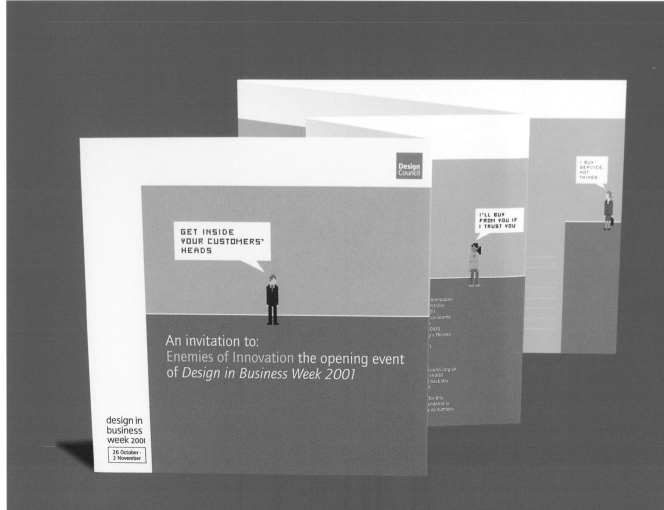

Design in Business Week 2001

To define identity across a wide range of media—from leaflet to stage set—requires a strong yet adaptable design concept. Based on the theme of this event—"Customer-Focused Design"—the designers have created a cast of ten "pixel people" to voice customers' needs and concerns. Working equally well in print and moving image, these characters are a refreshing and engaging contrast with clichéd, literal representations.

Designers
Paula Benson,
Paul West

Illustrator
Craig Robinson

Design Company
Form

Country of Origin
UK

Description of Artwork
Identity for *Design in Business Week 2001*, a UK Design Council event, including invitations, banners, stage set, and film

Dimensions
Various

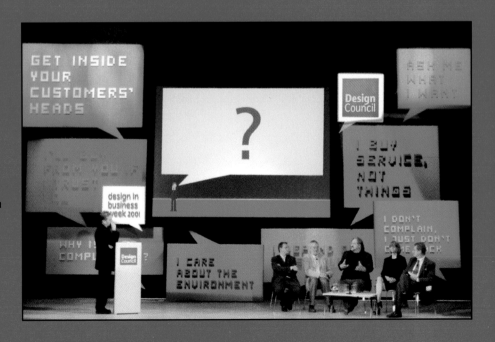

Illy

The success of this campaign proposal rests upon strong graphic identity and witty wordplay on the product name. Because of its simplicity, the concept would clearly stand up to multiple variations while still remaining fresh.

Designers
Dzurina Dzulkhaini,
Ifzan Ibrahim

Photographers
Dzurina Dzulkhaini,
Ifzan Ibrahim

Art College
Central St Martin's College
of Art and Design, London

Country of Origin
UK

Description of Artwork
College project to produce
posters promoting Illy
coffee

Dimensions
594 x 420 mm
$23^{1}/_{2}$ x $16^{1}/_{2}$ in

sistible

CCAC

CALIFORNIA College of Arts and Crafts
San Francisco/Oakland

CCAC

California College of Arts and Crafts
San Francisco/Oakland

OFFICE OF THE PRESIDENT

California College of Arts and Crafts

This set of stationery for the California College of Arts
and Crafts uses a multiplicity of typefaces to suggest the
history of this nearly 100-year-old institution. The college
has two campuses—one is primarily fine art and craft
oriented, the other is primarily architecture and design
oriented. To distinguish between the two while
maintaining overall identity, the stationery for each
campus is subtly different in its use of typography
and colors.

Designer
Bob Aufuldish

Design Company
Aufuldish & Warinner

Country of Origin
USA

Description of Artwork
Stationery for the California
College of Arts and Crafts,
including letterhead,
envelope, and business
cards

Dimensions
Various

CCAC

1111 **Eighth** STREET
San Francisco, CA 94107

www.ccac-art.edu

California College of **Arts** and Crafts

CCAC

Marilyn G. **da Silva**
jewelry/metal arts
program chair

510.594.3623
FAX 510.655.3541

CALIFORNIA College of ARTS and Crafts

Karakter

The designers have come up with various strategies to intrigue the recipient of this paper catalog. For example, insects are used as motifs to distinguish the four different groupings of paper. Offering page space to a font foundry to display their typefaces enables the capabilities of each type of paper to be shown in a real setting. This piece is much more than just a run-of-the-mill paper brochure: the quality of its design and its high production values make it instead a desirable artifact.

Designer
Eric Dubois

Art Directors
Eric Dubois, Marc Serre

Creative Directors
George Fok, Daniel Fortin

Illustrators
Eric Dubois, Marc Serre

Design Company
Époxy Communication Inc.

Country of Origin
Canada

Description of Artwork
Catalog to promote paper produced by Rolland Inc.— also featuring typefaces designed by Psy-Ops

Dimensions
150 x 177 mm
6 x 7 in

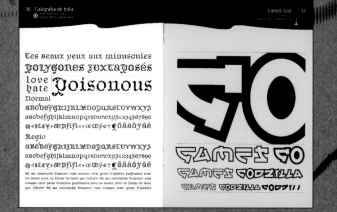

Printing
Impressi

r/ 2x black/r
erture pms 576

-4 2x black/r
1-44 pms 576
 pms 45

-8 2x black/r
7-40 pms 576
 pms 45

-12 2x black/r
3-36

3-16 2x black/r
9-32

7-20 2x black/r
5-28

21-24 2x black/r

Designers
Laura Husmann, Sara Ploehn, Carlos Segura, Tnop (Jamboree 1999—this page); Anisa Suthayalai, Tnop (Jamboree 2001—opposite page)

Art Director
Carlos Segura

Illustrators
Alex Wald (Jamboree 1999); Anisa Suthayalai, Tnop (Jamboree 2001)

Design Company
Segura Inc.

Country of Origin
USA

Description of Artwork
Branding, including posters, ads, T-Shirts, brochures, passes, and stage set, for the 1999 and 2001 incarnations of Q101's summertime "jamboree" rock concerts

Dimensions
Various

Q101 Jamboree 1999/2001

Each year this rock music event adopts a different theme—and graphic design is a vital tool in underlining the chosen subject. The 1999 theme was comic books, as can be seen in the promotional materials, with their explosions, flames, and 1950s typographic style. In 2001 the spotlight was on tourism and vacations. Each band on the bill had its own fridge-magnet—the retro designs resemble souvenir decals for tourist resorts.

of **DESIGNERS,
DESIGN COMPANIES,**
and **ART COLLEGES**

Hey, what's the Big Idea?